of EARTH *and* *Fire*

Maud Girard-Geslan

The T.T. Tsui Collection of Chinese Art
in the National Gallery of Australia

■ national gallery of **australia**

Edited, designed and produced by the
Publications Department
of the National Gallery of Australia, Canberra
Designed by Kirsty Morrison
Edited by Pauline Green
Colour separations by ColourboxDigital
Printed by Lamb Print

Cataloguing-in-publication data
Of earth and fire: the T.T. Tsui Collection of Chinese Art in the National Gallery of Australia.

Bibliography.
ISBN 0 642 54128 0

1. Tsui, T.T. – Art collections – Catalogs.
2. National Gallery of Australia – Catalogs.
3. Art, Chinese – Australian Capital Territory – Catalogs.
I Girard-Geslan, Maud.
II. Title.

709.51074

Distributed in Australia by:
Thames and Hudson
11 Central Boulevard Business Park, Port Melbourne, Victoria 3207

Distributed in the United Kingdom by:
Thames and Hudson
30–34 Bloomsbury Street, London WC1B 3QP

Distributed in the United States of America by:
University of Washington Press
1326 Fifth Avenue, Ste. 555, Seattle, WA 98101-2604

The Hong Kong entrepreneur, T.T. Tsui LLD JP, not only embodies the energy we see in the monumental intensity of that city, but he has taken on also the characteristic role associated with the past emperors of China — that of patron of the arts. In promoting his own cultural heritage, he has established important collections of Chinese art in major museums worldwide. The National Gallery of Australia became the beneficiary of Mr Tsui's benevolence initially in 1994 with the gift of an exceptional ceramic horse of the Eastern Han dynasty and, in 1995, with a further 30 important works of art.

In choosing the pieces of this gift I tried to include representative pieces of different periods, ranging from the neolithic period to the Qing dynasty. In media it includes bronze, stone, pottery, stoneware, porcelain and painted enamel on copper core. It is my sincere hope that this gift will strengthen the National Gallery of Australia's growing collection of Chinese art objects. It is also my hope that through these objects Australians, as well as Chinese communities in Australia, will better understand the great heritage of China. (T.T. Tsui, August 1995)

Acknowledgements

I would like to thank the Director of the National Gallery of Australia, Dr Brian Kennedy, for publishing this book which has given me great pleasure to research and to write; my patient, demanding and friendly, hawk-eyed editor, Pauline Green, who taught me more about English than most teachers; Suzanna Campbell for her support; and Kirsty Morrison for her beautiful work. And, in the first archaeological layer, Betty Churcher, the former Director of the Gallery, and Dr Michael Brand, both of whom honoured me with their trust in suggesting that I should write on the Tsui collection.

Many National Gallery staff in different departments have helped me in the course of my work: in particular, my colleagues in the Asian art department, now headed by Robyn Maxwell; Suzanna Edwards, Coordinator of Objects, Paintings and Textiles in the Registration department, who made the Tsui collection so accessible and helped me with equestrian terms in English; and others whose names sadly I may never know.

Lastly I thank my husband, without whose constant support I could not indulge in spending such a great deal of time in the past, and elsewhere, not meaning that I always try to forget where I have to be.

Maud Girard-Geslan

cover: *Jar* middle or 2nd half of 3rd millennium BC (catalogue no. 2)

CONTENTS

FOREWORD

The T.T. Tsui Gift to the National Gallery of Australia is indeed an impressive one and the Council of the National Gallery, through this publication, expresses its continuing appreciation to Dr Tsui for his generosity. At the time of the unveiling of the T.T. Tsui Gift, in August 1995, the then Prime Minister of Australia, the Hon. Paul Keating, commented on its importance to the people of Australia:

> Australia is very fortunate to have friends such as Dr T.T. Tsui. His gift of Chinese art to the National Gallery of Australia is of special importance, coming as it does at a time when Australia is actively seeking to strengthen links with our neighbours in the Asia–Pacific region. I am pleased to see that the National Gallery is working to acquire great works from Asia but I am also fully aware of the monumental task it faces as a very young institution. I am particularly delighted to see that the long history of art in China will now be made visible to all Australians at their National Gallery. These works of art will inspire a new generation of Australians to study and appreciate the culture of their neighbours in China.

The author of this publication, Mme Maud Girard-Geslan, is Chargée de mission au Musée national des Arts asiatiques-Guimet, Paris, singularly accomplished and published in her field, and with a first-class knowledge of the Chinese language.

Mme Girard-Geslan was a Visiting Fellow at the Research School for Pacific and Asian Studies, Australian National University, Canberra, from 1996 to the end of 1998. She provides intriguing insights and scholarly commentary on each of the objects in the T.T. Tsui Gift, which spans almost five millennia, from a neolithic painted pottery jar to a polychrome enamelled lidded vase from the eighteenth century. Each object is studied, commented upon and compared to its peers. Through Mme Girard-Geslan's approachable text the general reader will become acquainted with the art and traditions of one of the most distinguished of the world's civilisations, and the scholar of Chinese art and archaeology is offered much original and meticulous research.

As Director of the National Gallery of Australia, I am committed to developing an audience in Australia for Chinese art and to making it more accessible. We are particularly pleased, therefore, to publish the 31 objects which comprise the T.T. Tsui Gift, works which provide the visitor to the National Gallery, and now the reader of this book, with a promenade through splendid aspects of the long history of the arts in China.

Brian Kennedy
Director
National Gallery of Australia

INTRODUCTION

China is its own Greece and Rome. The only civilisation in the world to have a total cultural continuity from the third millennium BC to the present day, China finds its references in its own long history. Its remarkable intellectuals and civil servants produced for the benefit of kings and emperors a vast corpus of books, where the main questions generated in the human mind were addressed. They produced a treasury of concepts which enabled them to analyse and interpret the world with efficiency at the highest level.

Historical reflection began in a very tangible way during the Zhou dynasty when official recorders interpreted the victory of their masters over their predecessors, the Shang rulers, as the victory of virtue over vice. This conception of power wrested from another would link political life to ethics for centuries to come. Historians carried on the tradition. With the overt hope that their efforts would enable any new emperor to act in a better way, they drew on the lessons of the past, using careful reviews and reports, and providing good information and fine thinking. So did Sima Qian, 'The Great Historian' of the Western Han dynasty; so did all the others, sometimes paying dearly with their lives for their honesty and sense of the state's interest.

As far as the arts are concerned, at first during neolithic times and the Bronze Age, works were tightly linked to religious life and funerary practices. And since in China the biological link between the living and the dead is never cut, through royal ancestor worship the art of the bronze caster was at the heart of political life as well.

Legitimate rulers and usurpers, Chinese kings and emperors, and fast Sinicised barbarian founders of Chinese dynasties were patrons of the arts and devoted huge resources to express the genius and the ideology of their time and their aims. Arts and handicrafts received much attention, hence the existence of a huge reservoir of skilled and dedicated craftsmen during the entire known history of China. Interestingly, the idea of art for art's sake was born in China amongst the disillusioned members of the literati, in the politically troubled but culturally rich period between the fall of the Han dynasty (220) and the reunification of the country by the Sui emperor (581).

The patronage of rulers was essential for the grandeur of Chinese art. Art was part policy, part the project of a reign, and part the affirmation of a dynasty's identity, the expression of its culture. The emperor, the highest and the best amongst the rich and the mighty, gave directions, provided opportunities, threw fashions, and collected curios and masterpieces. Beautiful buildings harboured beautiful objects; they were decorated with fine wall paintings, the framework and windows could be carved or fitted with ornamental bronzes. The emperor's collection was personal and affected by the tastes and the knowledge of the collector which, at the same time, affected the state's and the nation's collections.

Aristocrats and merchants, literati and eunuchs, wives and concubines, could be avid collectors — for their aesthetic nourishment in this life and beyond the grave. Han defuncts could wish to be buried with cherished ancient bronzes or jades; Yuan aristocrats are known to have departed for the other world with precious Song porcelains and paintings. China has always been, and remains, a land of art connoisseurs.

Interestingly, Chinese art has always appealed to foreigners who did not spare effort and money to acquire precious objects from the great empire. Nomadic peoples of Central Eurasia were so fond of Chinese silks that they buried their dead chieftains with beautiful samples of embroidered fabrics, as did the Scythian riders in the fifth century BC at Pazyrik. Three centuries later,

Chinese emperors of the Western Han dynasty fed the steppic tribes' extravagant taste when they tried to bribe them with enormous quantities of silk rolls, in an effort to prevent these peoples from threatening the security and the sedentary economy of the northern frontier. In order to enhance their Mediterranean beauty, Roman ladies, used to all kinds of luxuries, indulged in expensive Chinese silks.

In the rain forests of Borneo as early as twenty centuries ago, some people were already using ceramics made in Han China, the shards of which have been recovered from riverbanks in Kalimantan. The Funan traders of the Mekong River delta in Southern Indochina imported Chinese bronze mirrors as well as Roman artefacts. The tribal chiefs and the Chinese merchants in the Southeast Asian archipelago, from Sumatra to Luzon, imported Song monochromes and Ming blue-and-white ware to enjoy in life and to take to the underworld.

Middle Eastern people were so obsessed with Chinese blue-and-white porcelains that, not only did they import them for the delight of their rulers, they started imitating them by applying cobalt blue motifs on the traditional faënza. What would Iznik ceramics be without the appreciation of Ming plates and bottles?

When the Europeans started competing to dominate the spice routes, they did not neglect the treasures of Chinese porcelains. Portuguese and Dutch sailors — in the fifteenth and sixteenth centuries — brought home enormous quantities of Ming blue-and-white porcelains, which nourished the inspiration of the Lisbon and Delft potters of the seventeenth century.

Most European royalty and the rich collected Chinese porcelains, often mounting them in Western style. As well as monochromes, such as light green glazed pieces — called celadons after the name of a character in a seventeenth-century French play — they collected blue-and-white and polychrome vessels. These pieces inspired eighteenth-century potters in Meissen, Sèvres or Limoges, amongst many other porcelain factories; and, in all important Western capitals, companies were established to trade with China.

The eighteenth century is characterised by its taste for 'Chinoiseries'. Motifs from Chinese paintings are seen on draperies, on vessels, and on furniture which cabinet makers started covering with lacquer and designing in rounded shapes, breaking with the stiffness of the previous century. Enamels — cloisonnés or painted — were in favour from London to St Petersburg, from Lisbon to Potsdam, as they were in the colonies from Brazil to the Philippines.

From the nineteenth century on, China became more accessible to foreigners and many archaeological objects and works of art — until that time unknown abroad, since merchants dealt with contemporary products — found their way into private and public collections in all parts of the world. Many of today's important museums of Chinese art inherited part of their collections from royal and private treasure cabinets.

With his generous gift to the National Gallery of Australia of this collection of Chinese works of art, Mr T.T. Tsui offers all Australians an unprecedented opportunity to get acquainted with one of the world's major civilisations. May some young visitors find a vocation and wish to link peoples through reciprocal knowledge of their cultures.

Maud Girard-Geslan

CHRONOLOGY OF CHINA

Neolithic time Incipient neolithic
Northeast, Hongshan culture, Liaoning, 3500–2500 BC
North, Yangshao, Yellow River Basin, Shaanxi, 5000–3000 BC
Yangshao, extension west, Gansu, 3500–1500 BC
Northeast, Dawenkou, Yellow River Basin, Shandong, 4500–2500 BC
Northeast, Longshan, Yellow River Basin, Shandong, Henan, Shanxi, 2500–2200 BC
Centre-southeast, Hemudu, Yangzi River, lower reaches, 5000–3000 BC
Centre-southeast, Majiabin, 5000–3000 BC
Centre-southeast, Liangzhu, Yangzi River, lower reaches, Hangzhou, Shanghai, southern Jiangsu, 3500–2000 BC
Centre-west, Daxi, Yangxi River Basin, Sichuan, 5000–3000 BC
Centre-south, Qujialing, Yangzi River Basin, middle reaches, 4000–3000 BC

Legendary Rulers It is impossible to match accurately the legendary rulers of China with the different cultural phases of the neolithic period. Nevertheless, it is interesting to compare the traditional dates and recently discovered archaeological evidence.
Fuxi corresponds to a pastoral age. He became a god. The inventor of writing and the Eight Trigrams, hunting and fishing nets, fire and cooking, music and musical instruments. He married his sister Nü Gua. Both have human heads and torsos and serpentine lower bodies, and are often represented with their lower bodies intertwined.
Shen Nong is the Farmer God and corresponds to an agricultural age.
Huangdi or You Xiong (2697–2599 BC) is considered the father of Chinese culture.
Yao or Di Yao or Yao Tang (2357–2258 BC), a demigod, chose Shun as his successor over his unworthy sons and gave him two daughters in marriage.
Shun or Di Shun or You Yu (2257–2208 BC), a demigod, the archetype of filial piety.
Yu or Da Yu (traditional date 2207), is the founder of the Xia dynasty.

Xia dynasty	**21st – 16th century BC**
	Late Longshan culture–early Bronze Age,
	Erlitou phase 18th – 17th century BC
Shang dynasty	**16th – 11th century BC**
	Erligang phase 16th – 14th century BC
	Anyang phase 14th – 11th century BC
	Several capital cities in Henan and Shanxi
Zhou dynasty	**11th century – 221 BC**
Western Zhou	11th century – 771 BC
	Capital city Hao or Feng (Shaanxi)
Eastern Zhou	770 – 256 BC
	Capital city Luoyi (Henan)
Spring and Autumn period	770 – 476 BC
Warring States period	475 – 221 BC
Qin dynasty	**221 – 207 BC**
	Capital city Xianyang (near Xi'an, Shaanxi)
Han dynasty	**206 BC – 220 AD**
Western Han	206 BC – 8 AD
	Capital city Chang'an (Xi'an, Shaanxi)
Xin dynasty (Wang Mang's usurpation)	9 – 25
	Capital city Chang'an (Shaanxi)
Eastern Han	25 – 220
	Capital city Luoyang (Henan)
Three Kingdoms	**220 – 280**
Wei	220 – 265
	Capital city Luoyang (Henan)
Shu Han	221 – 263
	Capital city Chengdu (Sichuan)
Wu	222 – 280
	Capital city Wuchang (Hubei)

Western Jin	**265 – 316**
	Capital city Luoyang (Henan)
Eastern Jin	**317 – 420**
	Capital city Jiankang (Nanjing, Jiangsu)
Northern and Southern dynasties	**386 – 589**
Northern dynasties	
Northern Wei	386 – 534
	Capital city Pingcheng (Datong, Shanxi)
Eastern Wei	534 – 550
	Capital city Luoyang (Henan)
Northern Qi	550 – 577
	Capital city Ye (Hebei)
Western Wei	535 – 556
	Capital city Chang'an (Shaanxi)
Northern Zhou	557 – 581
	Capital city Chang'an
Southern dynasties	
Song	420 – 479
	Capital city Jiankang (Nanjing, Jiangsu)
Qi	479 – 502
	Capital city Jiankang
Liang	502 – 557
	Capital city Jiankang
Chen	557 – 589
	Capital city Jiankang
Sui dynasty	**581 – 618**
	Capital city Chang'an
Tang dynasty	**618 – 907**
	Capital city Chang'an
Five dynasties	**907 – 960**
Later Liang	907 – 923
	Capital city Luoyang
Later Tang	923 – 936
	Capital city Luoyang
Later Jin	936 – 946
	Capital city Pian (Kaifeng, Henan)
Later Han	947 – 950
	Capital city Pian (Kaifeng, Henan)
Later Zhou	951 – 960
	Capital city Pian
Song dynasty	**960 – 1279**
Northern Song	960 – 1127
	Capital city Pian
Southern Song	1127 – 1279
	Capital city Linan (Hangzhou, Zhejiang)
Liao dynasty	**916 – 1125**
	Capital city Yanjing (Beijing)
Jin dynasty	**1125 – 1224**
	Capital city Zhongdu (Beijing) and Kaifeng (Henan)
Yuan dynasty	**1271 – 1368**
	Capital city Karakorum (Mongolia) and Yanjing
Ming dynasty	**1368 – 1644**
	Capital city Nanjing and Beijing
Qing dynasty	**1644 – 1911**
	Capital city Beijing
Republic of China	**1911 – 1949**
People's Republic of China	**1949**

1. JAR

buff earthenware with painted decoration
50.0 x 36.0 cm (diam.)
Neolithic period, late Yangshao culture
early 3rd millennium BC
1995.586

The jar — with its medium high flaring neck and rounded shoulder separated from the neck by a large flat area, its slightly tapering lower body, two small lug-handles attached under the shoulder, and its narrow base — bears the characteristics of the last period of the Majiayao phase of the Gansu Yangshao–Majiayao culture.

The brown colour of its decoration makes this an exceptional piece, since painted decoration from this cultural phase is most commonly encountered in black. However, the structure of the decoration is classical.[1] Parallel bands of unequal width circle the neck and the flat area of the shoulder. The shoulder is covered by two systems of parallel thin lines regularly crossing each other to form a net pattern.[2] Three parallel lines, one thin between two thicker ones, echoing the decoration of the upper part of the vessel, lead to a band adorned by small 'x'-shaped motifs, the significance of which remains unclear. Two registers of parallel horizontal lines lead the eye to the lowest part of the decoration where oblique slightly curved lines give the impression of a turning movement. The foot is left unadorned. The vessel, like most contemporary pieces, is well burnished.

Recognised by J.G. Andersson in 1923 as a western offspring of the Shaanxi neolithic culture of Yangshao, maybe originating in the penetration of Yangshao tribes into Gansu,[3] the Majiayao culture spread widely from the Shaanxi–Wei river basin well into neighbouring Qinghai and Gansu provinces, where it preceded the Banshan and Machang phases, the former of which is also represented in the Tsui gift (see catalogue no. 2).

A piece of fine quality, most probably part of the grave goods excavated in a cemetery, this jar is by no means a mere utilitarian vessel— which in this culture were gritty red pots. It was meant to be beautiful and part of a special inventory. The jar remains quite puzzling because of its large dimensions and its profile which place it between the classical small *hu* wine container and the classical large *guan* storage jar — which makes it still more interesting.

1 For a *hu* jar bearing a related decoration, but of smaller dimension, see Gansu Provincial Museum, *Gansu caitao*, Beijing: WWCBS, 1984, pl. 22, the *ping*, pl. 32, has the same type of handles (lower part of the neck). For a good synthesis on early Chinese ceramics, see Clarence Shangraw, *Origins of Chinese Ceramics*, New York: China Institute of America, 1978.
2 This pattern is commonly found on painted *hu*, *guan* and even *pen* basins, belonging to the Banshan phase of the Majiayao culture, *cf. Gansu caitao* (1984), pls 22, 36, 41, 70, 105, 114.
3 J.G. Andersson, 'Prehistory of the Chinese', *Bulletin of the Museum of Far Eastern Antiquities*, 15 (1943), 7.304.

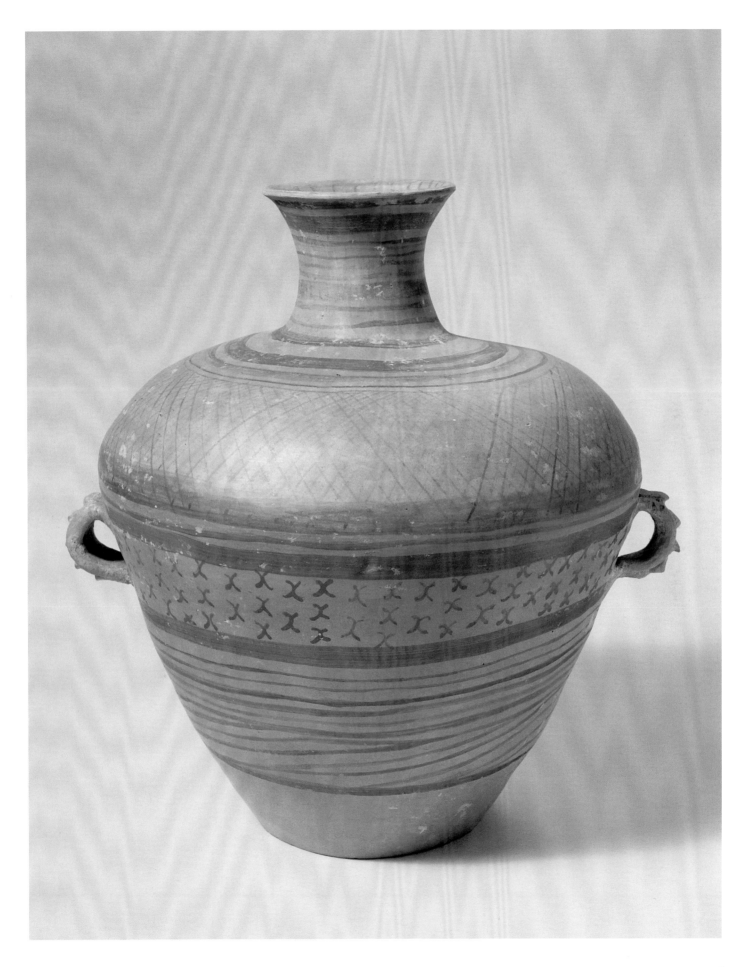

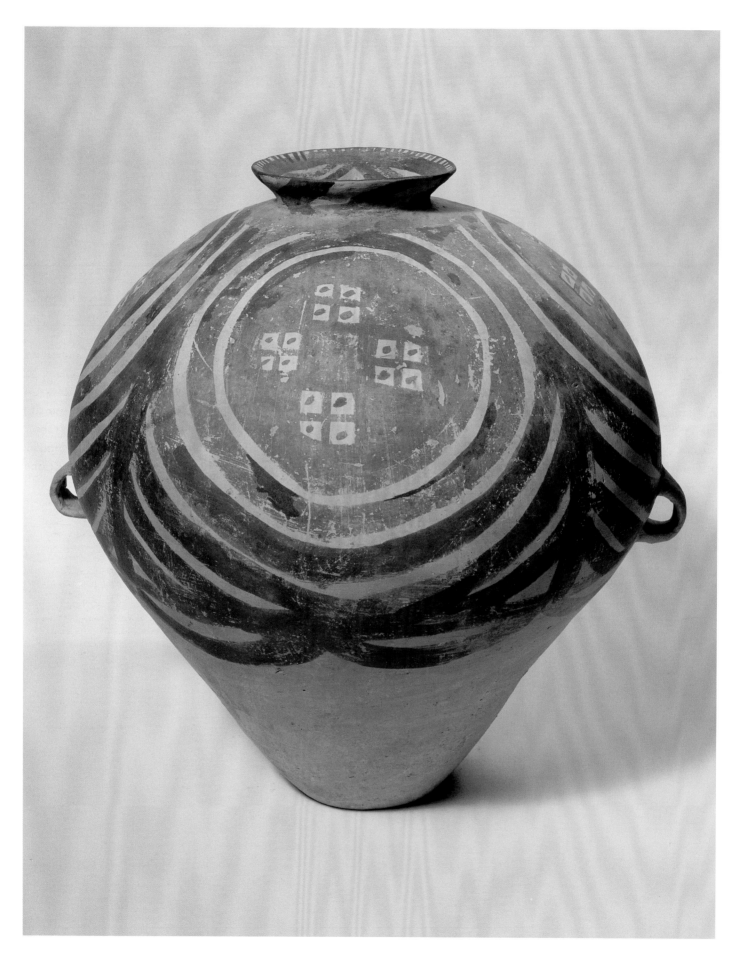

2. JAR

buff-red earthenware with painted decoration
42.0 x 41.0 cm (diam.)
Neolithic period, late Yangshao-Majiayao culture, Banshan type
middle or 2nd half of 3rd millennium BC
1995.595

With its low, slightly spreading neck, broad rounded shoulder, small loop handles, flaring sides and narrow flat bottom, this globular jar is typical of the Banshan type of the Gansu late Yangshao culture.[1] First identified by J.G. Andersson near Lanzhou in 1923,[2] this Banshan type of ceramic ware is encountered in the western central part of Gansu province.

The small neck is adorned on the outside with broad oblique parallel black bands and is underscored with an indented black band. Inside the rim, small vertical lines lighten the broad outlining band, and narrower bands act as garlands beneath. The main painted decoration consists of a series of four concentric circles, alternately black and maroon. The inside of each circle is filled with a cruciform pattern made of four checkered motifs, reminiscent of cultivated fields. Broad semi-circular black bands beneath the four main motifs have been applied in a supple manner; they meet vertical lines which mark the four segments of the decoration. A horizontal band and a row of garlands, echoing the ornamentation inside the neck, completes the decoration of the belly, adding rhythm and organicity.[3]

Traces of maroon appear in between the inner circles and the cruciform motifs. The contrast of black on buff colour is striking and gives an impression of strength and harmony. Such mastery of the decorative surface is typical of the best period of the Banshan culture.

The jar is made by the ring-coiling method in two parts (plus neck and bottom), luted together at the shoulder. The wall of the vessel is flattened and polished — a spatula would have been used on the outside and, on the inside, an anvil. Pieces such as this jar were fired at a temperature between 760° and 1020°C.

Formerly considered as funerary urns, these jars are now recognised also as storage vessels. Archaeological evidence shows that as well as grave goods in cemeteries,[4] they could have been used in villages as grain containers.[5] In either instance, the quality of vessels such as this Tsui jar would classify them as vessels of prestige.

Banshan type jars have been discovered in huge quantities in recent decades (sometimes alongside Majiayao type artefacts) in large cemeteries of the Gansu late Yangshao culture, and numerous such pieces have appeared on the international art market where their beautiful polish and lively decoration make them fine collectors' items. Similar pieces are held in all important international collections of Asian art.[6]

1 *Cf.* Gansu Museum et al., 'Lanzhou Tugutai Banshan–Machang wenhua mudi', KGXB, 1983/2, pp. 191–217, and pl. 21, figs 10, 12, to a lesser extent pl. 20, fig. 12.
2 *Cf. supra*, catalogue no. 1, note 3.
3 A beautiful jar kept in the Shanghai Museum is extremely close to the National Gallery of Australia's piece, but for the four motifs inside the circles. The Shanghai jar (about 10 cm higher but of similar proportions) is decorated with a net-like pattern inside three double circles set inside the four 'tondo'. cf. Shen Zhiyu, *The Shanghai Museum of Art*, New York: Abrams, 1985, pl. 24.
4 *Cf.* Qinghai province archaeological group of the Bureau for cultural relics, 'Qinghai Ledu Yangwan yuanshi shehui mudi fanyang chude zhuyao wendi', KG, 1976/6, 'Qinghai Ledu Yangwan yuanshi shehui mozang diyici fajuede chubu shouhuo', WW, 1976/1, pp. 67–78, and Gansu Provincial Museum, *Gansu caitao*, Beijing: WWCBS, 1984.
5 *Cf.* 'Gansu Lanzhou Qinggangcha yizhi shijue jianbao', KG, 1972/3, pp. 26–31; fig. 7 shows three pictures of *guan* jars excavated inside house 1.
6 *Cf.* at the Musée national des Arts asiatiques-Guimet, Paris, jar MA 5866, J.-P. Desroches *et al.*, *La Chine des origines*, Paris: RMN, 1994, pp. 10–11.

3. *FU* RITUAL VESSEL

bronze
9.4 x 18.8 x 31.0 cm
not inscribed
late Western Zhou or early Spring and Autumn period
8th century BC
1995.576

A good example of the rectangular *fu* shape, this bronze vessel is made of two symmetrical parts, a bowl and a lid, which can be used alongside one another as separate food containers. Both are trapezoidal with a rectangular cross-section. Four little feet at the corners of the flat base and lid (which act as a crown when the lid is in place) are stylised gaping tigers.[1] Two looped handles, adorned with a small animal mask swallowing a bird's head,[2] are set on the short sides of the bowl and the lid.

The vessel bears a compartmentalised ribboned decoration of angular sinuous dragons seen in profile. The bodies are incised with a single line. The eyes, treated in flat relief, appear at the centre of each half panel on the vessel's long sides. They are symmetrically arranged in a manner reminiscent of the *taotie* animal masks of the Shang and early and middle Western Zhou periods. The decoration of the flat base (a dissolved animal shape) is organised around a central eye motif in relief of the 'coffee bean' type. The rims are adorned with a row of double angular spirals — slightly smaller on the lid than on the base.

The patina is crusty, greenish with some bright green spots; in places the greyish alloy, rich in tin, appears in its original state. This *fu* has been pierced — maybe due to the pressure of burial earth on an angular object in contact with the inside wall of the lid, or maybe due to negligent digging.

The shape, with its sloping walls, flat rims and small indented feet (the snout, legs and tail of the tigers), is consistent with an early Spring and Autumn date, although the decoration retains some characteristics of the late Western Zhou period, which is not uncommon in *fu*.[3]

A regional provenance is difficult to assess since such pieces were quite widely used, but the style of decoration would pledge for a northern provenance, in the Yellow River basin, where related vessels have been discovered from the Shaanxi province to the west to the Shandong province to the east.

The *fu* ritual rice container appeared during the late Western Zhou period (9th – 8th century BC),[4] became fairly common during the Spring and Autumn period, and remained in use during the Warring States period (5th – 3rd century BC). The name *fu* was used by Song dynasty (960–1279 AD) scholars to designate this type of vessel.[5] Evidence from archaeological discoveries in mainland China during the last decades of the twentieth century indicates that inscriptions on such pieces often 'self-name' the vessel *gui*. The *Zhouli* (Ritual of Zhou)[6] mentions that *fu* and *gui* are used for *si* sacrifices — offerings of grain to gods, spirits or the dead.

Since the early Shang dynasty, the *ding* tripod meat cooking vessel and the *gui* grain presentation bowl had been the main food vessels used in rituals during sacrifices and funerary ceremonies.[7] Buried with kings and aristocrats according to definite rules (which developed into a fairly strict system under the Zhou dynasty — an odd number of *ding* and an even number of *gui*, with a maximum of nine *ding* and eight *gui* for the Son of Heaven), the ritual bronzes were the privileged testimony of a noble defunct's rank in society. They accommodated him in the underworld.

During the Western Zhou period, the spread of rice, from central and south-eastern coastal China to northern areas of the country, led to its use in rituals where, for centuries, millets had been the only cereals offered to deities, ancestors and the dead.[8] During the late Western Zhou time, *fu* vessels appeared amongst burial furniture (replacing the even number of *gui*). During the early Spring and Autumn period (8th – 7th century BC) both types appear together in funerary inventories.

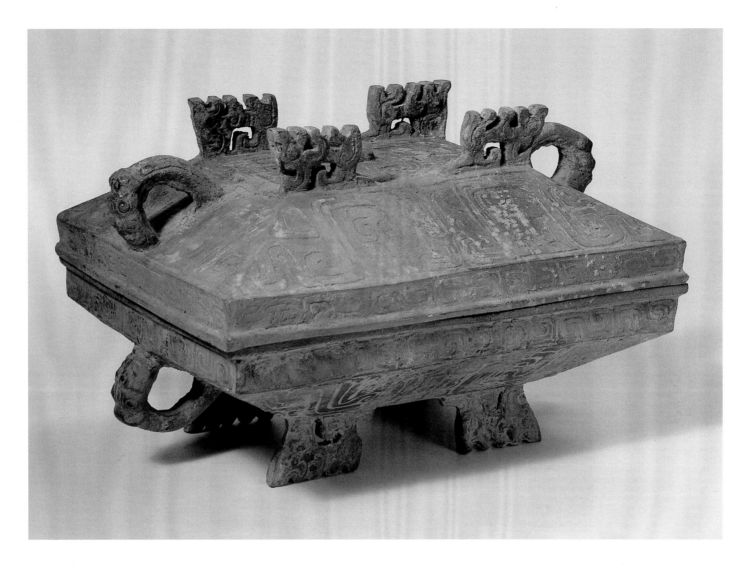

1　A famous Spring and Autumn *fu* excavated in 1961 in Feicheng in the eastern province of Shandong has the same type of feet, see *Zhongguo gu qingtong qi,* Beijing: WWCBS, 1976, pl. 48, and *Xin Zhongguo chutu wenwu,* Beijing: Waiwen CBS, 1972, pl. 62.

2　This is the classical pattern for handles of grain vessels of the Shang and Western Zhou dynasties.

3　For instance in *fu* B60 B1029 kept in the Avery Brundage collection, see R.-Y. Lefebvre-d'Argencé , *Bronze Vessels of Ancient China,* San Francisco: Asian Art Museum, 1977, pp. 104–105, pl. 44. A *fu* from tomb M4078 of the Shangmacun cemetery, in Shanxi province dating to the early Spring and Autumn period bears a related decoration, *cf.* Shanxi Province Institute of Archaeology, *Shangma mudi,* Beijing: WWCBS, 1994, p. 53, fig. 40, illus. 1.

4　It may have derived from an early Western Zhou rectangular vessel, which itself has been inspired by the shape of bamboo containers, as mentioned by Li Xueqin in *The Wonder of Chinese Bronzes,* Beijing: Foreign Language Press, 1980, p. 12. Like the *xu,* a rectangular squat vessel appeared during the middle period of the Western Zhou dynasty, it has been considered an offshoot of the *gui,* but it is more a matter of functionality than of morphological origin, if one supports Li's theory. Among the early ones, the *Bo Gong Fu fu,* (19.8 x 28.3 cm) famous for its two 61-character inscriptions, dating to the late Western Zhou, was excavated in 1977 from hoard no. 2 at Yuntangcun in Fufeng, in the Shaanxi province, *cf.,* Shaanxi Institute of Archaeology, *Shaanxi chutu Shang Zhou qingtong qi,* Beijing: WWCBS, 1980, vol. 3, pl. 94, pp. 98–99.

5　Their researches and speculations about the terminology of bronze ritual vessels are still useful today and are well complemented by new archaeological data. All problems of terminology are not solved though, self-naming inscriptions may yield some clues but they can add to the confusion as well, by introducing previously unknown vessels' names or variants in characters. For a discussion on the name *fu,* see Gao Ming, '*Gu, fu kaobian*', in WW, 1982/6, pp. 70–73.

6　Quoted by Ma Chengyuan in *Zhongguo qingtong qi,* Shanghai: Shanghai guji, CBS, 1988, p. 149; Zheng Xuan's commentary states that, when quadrangular, the vessel is called *fu,* when round it is called *gui.* Elsewhere it clearly indicates that *fu* are used for rice.

7　It is interesting to mention that during the Shang dynasty the most numerous ritual bronze vessels were by and large the wine vessels. When the Zhou replaced the Shang kings they interpreted their victory as the triumph of virtue over vice, they were convinced that the Shang had lost heaven's mandate because of their indulgence in ribaldry and excessive use of alcoholic beverages far beyond the needs of sacrifices. After a period of observance of rituals close to the Shang royal ceremonies, the Zhou developed a ritual of their own which led to the disappearance of most wine vessels dear to the Shang (*jue, jia, jiao, gu*). The emphasis was then put on the food vessels, as it had been during the predynastic Zhou period.

8　Millets (*ji,* probably *Setaria italica* Beauv., foxtail millet and *shu,* probably *Paniculum miliaceum* L., panicle millet) *cf.* Chang Te-tzu, 'Origins and Early Cultures of the Cereal Grains and Food Legumes', in David N. Keightley (ed.), *The Origins of Chinese Civilization,* Los Angeles/London: UCLA Press, 1983, p. 66. Millets were the staple crops in the Yangshao (5th–late 3rd mill. BC) and Longshan (3rd mill. BC) neolithic cultures in the Yellow River basin in northern China, whereas rice was cultivated in the middle Yangzi area in the Qujialing neolithic culture (1st half 4th mill. BC) and in the lower Yangzi basin in the Hemudu (early 6th mill. BC) and Majiabin (5th mill. BC) cultures. In the coastal culture of Qingliangang (*c.* 4600 BC) the nature of the staple crop remains uncertain, see M. Girard-Geslan, 'Cultures du nord, cultures du sud, les Néolithiques chinois', *Archéologie,* Les Grands Atlas Universalis, Paris: Encyclopaedia Universalis, 1985, pp. 260–261.

4. DUCK-SHAPED VESSEL

painted grey earthenware
18.5 x 17.0 x 25.0 cm
Western Han dynasty 206 BC – 8 AD
1995.588

Cocking its head, stretching its long neck out from its globular body, raising its flat tail and flapping its two small wings, the stylised duck stands firmly on its two flat rounded feet, ready to pour wine. Traces of white and red brushstrokes — mostly circular and meant to imitate the aspect of feathers — remain visible on the surface of the grey earthenware. The vessel was made in separate moulded pieces — head, neck, lid, detachable wings and tail, legs and body — then luted together.

The open beak may lack the typical flatness of a duck's beak, the eyes may look surprisingly protruding, the wings may be rectangular, the spine may be fitted with a strange little lid, and the legs may seem too cylindrical on the trumpet-shaped feet; it is nevertheless a very lively figurine of a waddling duck which stands in front of the viewer.

Since neolithic times animal-shaped ritual vessels were part of grave goods for defuncts of high rank. During the last period of the Miaodigou phase of the Yangshao culture

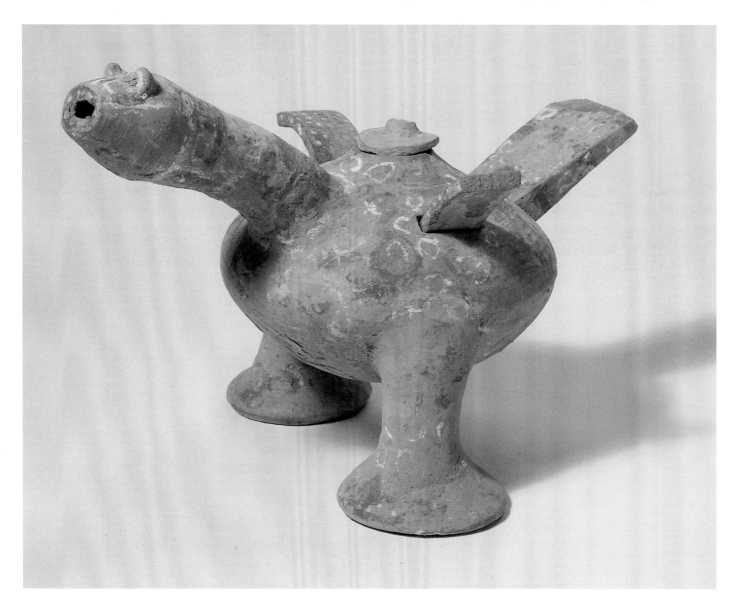

(4th mill. BC), a noblewoman from Taipingzhuang (Huaxian, Shaanxi province) was buried with an extraordinary finely burnished grey aviformic tripod in the shape of an owl.[1] The other most famous zoomorphic vessel is a red pig-shaped tetrapod, excavated from tomb 9 in Dawenkou (Tai'an, Shandong province 4th – 5th mill. BC).[2]

Making bird-shaped liquid containers was not an uncommon practice. In Longshanoid cultures the neolithic potters produced bird-like profiled *gui* ewers, although without any clear realistic reference. A piece such as *gui* 98:14 from Dawenkou conjurs up the plump silhouette of the duck which has haunted the Chinese countryside for centuries.[3]

Although one of the earliest forms of bird-shaped bronze wine containers, the closed-top *he* ewer dates back to the end of the Erligang (16th – 14th century BC) or the beginning of the Anyang phase of the Shang dynasty (13th – 11th century BC),[4] it is during the thirteenth and twelfth centuries BC that the Chinese particularly favoured wine containers in the shape of birds (mostly owls).[5] The Western Zhou period produced very fine duck-shaped bronze *zun* wine containers, such as the Kazuo four-legged *he* (Liaoning province),[6] the Pingdingshan (Henan province) and Dantu *zun* (Jiangsu province pieces).[7]

The Warring States Chinese people carried on with the casting of aviformic bronze wine vessels. A *zun* kept at the Nelson Gallery, Atkins Museum (Kansas City) is morphologically related to the Tsui piece (although it is not a duck), with high head, protruding rectangular wings (parallel to the body), small opening on the spine and short tail. It is even possible that the gold inlay scale-like feathers, as found on the Kansas City *zun*, could have inspired the craftsmen producing modest earthenware vessels in their treatment of the painted surface.

An earthenware duck-shaped *zun*, black with a beautiful burnished surface — almost as aristocratic as a bronze ewer — was buried in King Cuo's mausoleum in the northern kingdom of Zhongshan during the Warring States period.[8]

Closer in spirit to the Tsui piece is a strange grey pottery bird with a wide open beak-mouth, triangular ears and detachable wings and tail, dating back to the Warring States period (Nelson Gallery, Atkins Museum).[9]

The Western Han potters, from today's Shandong province, produced amongst many lively *mingqi*, funerary objects,[10] two big (40.5 x 52.5 cm) terracotta pigeons whose widely-spread wings carry, in one case, two *ding* tripods and five human figurines and, in the other case, two *hu* wine containers. Both pieces were excavated from a tomb at Wuyingshan (Qinan).[11] Although more monumental, they are stylistically relatively close to the Tsui duck-shaped vessel. While quite close to the style of Warring States, the piece in the National Gallery of Australia can be dated back to the Western Han dynasty and originate from Northern China.

1 KGXB 1965/1, and Peking Museum of Chinese History, *7000 Years of Chinese Civilization*, Milan: Silvana Editoriale, 1983, p. 89.
2 *Cf.* Shandong Provincial Bureau for Cultural Relics and Qinan City Museum, *Dawenkou*, Beijing: WWCBS, 1974, pl. 88.
3 *Cf. ibid.* pl. 77 illus. 5.
4 *Cf.* Maud Girard-Geslan, in J.-P. Desroches *et al.*, *La Chine des origines*, Paris: RMN, 1994, pp. 88–89.
5 Well-liked by American collectors. The most famous of all is the very striking *zun* 785 from Fu Hao tomb in Anyang. *cf. Yinxu Fu Hao mu*, Beijing: WWCBS, 1980, pl. 7. Strangely enough the Han potters kept a liking for owl-shaped wine vessels, see E. Schloss, *Art of the Han*, New York: China House Gallery, 1979, p. 77, no. 53, and, for another one, at Musée Cernuschi, Paris, M.-T. Bobot, *L'Art chinois*, Paris: Desclée De Brouwer, 1973, fig. 30.
6 *Cf. Wenwu cankao ziliao*, Beijing: 1955/8, pl. 12.
7 *Cf. Gems of China's Cultural Relics*, Beijing: WWCBS, 1990, pls 49, 50. Chinese/English.
8 It was exhibited in Paris in 1984, *cf.* Danielle Elisseeff-Poisle and J.-P. Desroches, *Zhongshan: Tombes des rois oubliés*, Paris: MAE, AFAA, 1984, pl. 83.
9 No bibliographical reference, personal photograph.
10 A *mingqi* is a funerary object, a piece in the inventory of tomb furniture/grave goods which was specifically made for burial. It is sometimes difficult to know if an object found in a tomb had been used in everyday life, in ceremonial life, or was made just for burial.
11 *Cf. Wenhua da geming qijian chutu wenwu*, Beijing: WWCBS, 1973, pp. 126, 127.

5. KNEELING FIGURINE OF A LADY

painted grey earthenware
h: 56.0 cm
Western Han dynasty 2nd or 1st century BC
1995.580

This kneeling figurine has been considered to be a male by some scholars; but it is actually the figure of a woman. Although the hands are missing, the attitude of the arms suggests that the woman may be presenting some kind of offering to the master of the tomb in which the figure was buried. What could be a male[1] or a female head[2] has been put on a female body at an undetermined time — possibly the original head broke apart from the body at the time of burial.

Long hair is painted on the back of the robe. But on the head, the hairline stops at the nape of the neck; there is no continuity between the hair on the head and the painted hair on the robe — which is a loose and low bun tied at mid-back, from which a thin tuft escapes.[3] It is a classical woman's hairdo of the time.

The head which is currently fixed to the body is of good proportion and of the same period as the body. The black hair is parted in the middle in a fashion that is found on both male and female *mingqi*, funerary figurines. At each corner of the hairdo there is a small hole, probably made to be fitted with an ornament.[4] The face, painted in white (as is the neck), is of the rectangular rounded type. The nose and the delicate small mouth are modelled in the clay, whereas the eyebrows and eyes, while modelled, are also described with a supple thin brush laden with black ink. The expression is of a formal reserve and dignified affability.

The long, wide, outer garment, with medium large sleeves, covers three underrobes of similar shape. The robes — which resemble today's Japanese *kimono* — cross classically, left over right.[5] The outer garment is painted in a brownish colour which, over most of the surface, has peeled off. Its border, at the collar as well as at the wrist, is adorned with a maroon band bearing motifs of four red dots arranged in a lozenge pattern. A red belt underlines the waist and hangs down in the centre of the skirt. The three underrobes, painted with a white slip, are bordered with red at the collar and at the sleeves. The discreet decoration of floral rhomboidal motifs on the edge of the outer robe alerts the viewer to the sophisticated weaving techniques of China at this early time.[6]

The Cernuschi museum in Paris holds the closest known piece to the Tsui kneeling figure.[7] The Guimet museum in Paris (donation J. Polain, MA 6092) has a standing lady (h: 78 cm) with the same hairdo and a very similar dress.[8]

This figure is kneeling, which was the correct way to sit (*zhengzuo*) during the Han dynasty (as is still the case in Japan). Officials and high ranking people sat formally (actually knelt) on low wooden couches covered with straw mats fringed with silk bands. Kneeling figures are not very common amongst Han *mingqi* who are mostly standing.[9]

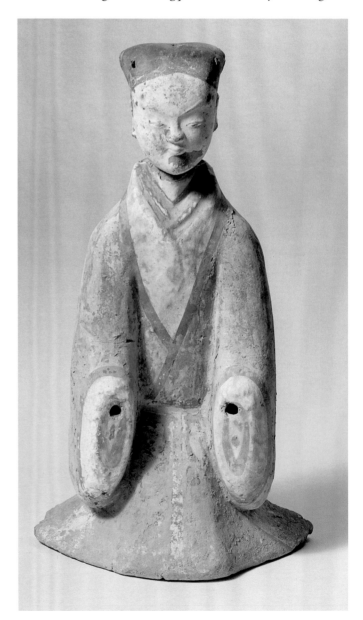

A second century BC Han tomb at Jinjueshan, in Linyi (Shandong province) has yielded standing figurines of women wearing similar attire[10] and a funerary banner (not unlike the famous Mawangdui banner).[11] The central part of the banner, where the defunct is pictured formally seated, shows four women — three are standing, while the fourth, holding a container of some kind, kneels in front of the mistress of the tomb; she is probably paying respect, maybe presenting an offering.

During the Han dynasty, the habit of providing the deceased with burial furniture continued to flourish. The sacrifice of human victims — to follow rulers and aristocrats into the underworld — well known during the Shang dynasty and occasionally occurring during the Han time,[12] had been widely replaced for several centuries by the use of figurines. This important change in funerary

mores was attributed to Confucius' disapproval of such a barbaric and morally unacceptable practice.

The richer the defunct, the better and the more numerous were the grave goods. Beside ritual vessels made of bronze, lacquer or ceramic (painted or glazed), there were figurines of court ladies, soldiers or attendants, made of ceramic or wood, sometimes bronze.[13] The ceramic figurines were moulded and fired in pieces — the heads and hands very often mounted separately. The fine details were modelled with a knife or delicately painted with a small brush on the white slip.

The rather large size of the Tsui figurine (h: 56 cm) — which, if standing, would be comparable to the Guimet piece — and its fine style, pledge for a very good provenance: the last resting place of someone in the imperial entourage; or the grave of a feudal lord in northern China, maybe in Shaanxi province in the vicinity of the Han capital Chang'an, or elsewere, perhaps in Henan province not far from Luoyang. A photograph of a beautiful figurine of a kneeling male, the size of which is not mentioned, appears in *Zhongguo lidai fushi shi* (1984). Despite its different posture and costume, its Shaanxi origin (Xianyang) and its quality would make it a perfect match for this piece in the National Gallery of Australia's collection.[14] Amongst public collections in Australia, the Art Gallery of New South Wales and the National Gallery of Victoria also keep fine Han figurines.[15]

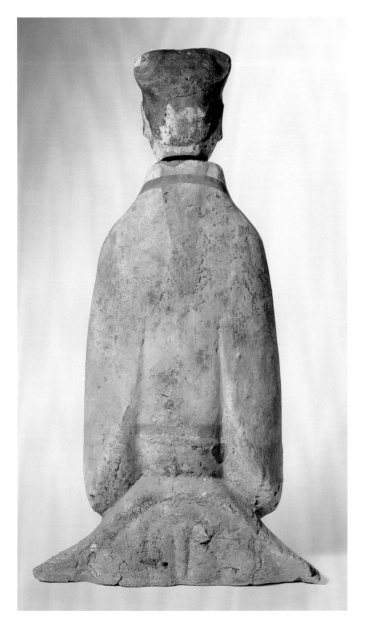

1 Because of the lack of detail at the back of the head.
2 A hairline at the nape level appears on female heads whose hair is gathered up at the upper part of the back of the head, as on a very similar kneeling lady figurine kept in the Palace Museum in Beijing, *cf.* Zhou Xibao, *Zhongguo gudai fushi shi*, Beijing: Zhongguo xiju CBS, 1984, p. 117, fig. 30, illus. 1.
3 For several such examples see *ibid.* fig 13, illus. 1, 2, 3.
4 As on the Cernuschi kneeling lady, see *infra*, note 7.
5 *Cf.* the basic type Zhou Xibao, *Zhongguo gudai fushi shi* (1984), p. 108, fig. 10.
6 One of the most impressive archaeological discoveries from the Han period for the study of textiles and costume is the grave of Marchioness Dai at Mawangdui in Hunan province. *Cf. Changsha Mawangdui yihao Han mu*, Beijing: WWCBS, 1973. The best book about Chinese ancient costumes remains Zhou Xibao's *Zhongguo gudai fushi shi* (1984).
7 *Cf.* M.-T. Bobot, *Chine connue et inconnue*, Paris: Paris Musées, 1992, pl. 38, p. 89.
8 *Cf.* J.-P. Desroches, *Chine, Des Chevaux et des hommes*, Paris: RMN, 1995, p. 59.
9 A group of kneeling figurines was uncovered in Xi'an at Renjiapo, in an annex pit belonging to Empress (Tai Hou) Dou of the Western Han dynasty. *Cf.* KG, 1976/2, pl. 7, illus. 2, 3.
10 WW, 1977/11, fig. 4, p. 26.
11 *Cf.* 'Jinjueshan Xi Han bohua linmo hougan', *ibid.* fig. 2, p. 29 and pl. 1. For the very famous Mawangdui banner, see *Changsha Mawangdui yihao Han mu*, Beijing: WWCBS, 1973, vol. 2, pls 71–77.
12 For instance, in Southern China human victims were buried with the Chinese ruler of the Nanyue kingdom in Guangzhou (Guangdong), see *Xihan Nanyue wang mu*, Beijing: WWCBS, 1991, pp. 17–18, and in two of his officials' tombs at Luobowan, in Gui county (Guangxi), see *Guangxi Guixian Luobowan Hanmu*, Beijing: WWCBS, 1988, pp. 13–18.
13 A fine gilded bronze figurine of a kneeling lady wearing the same robe as the Tsui piece has been excavated from an early Han tomb in Guangzhou. See *Guangzhou Han mu*, Beijing: WWCBS, 1981, vol. 2, pl. 36.
14 *Zhongguo lidai fushi shi*, Shanghai: Xuelin CBS, 1984, pl. 77, p. 51.
15 See J. Menzies, *Asian Collection*, Sydney: Art Gallery of New South Wales, 1990, p. 21, (others have been acquired since), and M.A. Pang, *An Album of Chinese Art*, Melbourne: National Gallery of Victoria, 1983, pp. 68–69.

6. *HU* CONTAINER

green-glazed ceramic
50.5 x 30.0 cm (diam.)
Han dynasty 1st century BC – 2nd century AD
1995.577

This green-glazed pottery *hu* wine container is comparable in shape and style to contemporary bronze *hu* — with its mouth of the *pankou* type (dished-mouth) and its high cylindrical neck rising out of a bulbous body supported by a flaring foot.

The sparing use of decoration — carved parallel lines, four on the mouth, two at the shoulder, two slightly above the girth, punctuated by moulded *pushou* (mask-and-ring) motifs at the shoulder — gives this monumental jar a charming plainness as well as a robust simplicity which is the hallmark of the Han potter's craft.

Made of fine-grain grey clay, the vessel was thrown on the wheel, with the foot built separately and applied to the body. Brown then green lead glaze became popular for funerary pieces during the second half of the Western Han dynasty. The taste for green led to the decline of the brown glaze. Long periods of burial can give the glaze an iridescent aspect. This *hu* is in good condition, the glaze remains almost in its original state.

Since the neolithic times, the dead, especially the rich and powerful, kept their rank and status beyond the grave. During the Bronze Age, defunct Shang and Zhou rulers and their kin and allies were lavishly provided with bronze ritual vessels and musical instruments. During the Zhanguo or Warring States period (5th – 3rd century BC) their wide use beyond the royal frame of the Zhou courts by many feudal lords, even of very small principalities, led inevitably to a process of secularisation. Such bronze objects became essentially prestige items to be enjoyed as luxuries and to be offered as diplomatic gifts. Nevertheless, the elite kept the custom of carrying their treasures to the grave.

Some of the types of bronze ritual vessels and their ceramic peers continued to be used during the Han time, such as the *ding* tripod meat vessel and the *hu* wine container. The trend towards simplification, both in shape and decoration, initiated in the Qin kingdom at the end of the Warring States period and during the reign of Qin Shihuangdi (the founder of the Chinese empire) 221–207 BC , generally continued during the Han dynasty.

Wealthy defuncts departed for the underworld, not only with a number of ritual vessels and musical instruments, but with numerous commodities as well, which were meant to cater to their material needs as if life were to continue in the same manner after death. Sometimes incredible quantities of food and beverages were kept in side chambers of their tombs, in bronze or even more precious lacquer containers.[1] Thus ceramic containers, either painted or glazed, more or less imitating the aspect of bronze in shape and colour, became the main type of funerary objects, even for members of the imperial family.[2]

The principal kilns producing funerary objects for the aristocracy were located in the vicinity of Chang'an and Luoyang, the two capital cities of the Han. Green pieces such as this *hu* were widely distributed in central China. Of rather large size and good quality, its shape quite close to the shape of contemporary bronze *hu*, and its beautiful green glaze emulating the deep shade of a good bronze patina, the Tsui piece comes probably from one of the main kiln sites. The proposed date would be the late Western Han or the Eastern Han period. All major museums of Chinese art keep such pieces.

1 *Cf.* Esson M. Gale, *Discourses on Salt and Iron,* Sinica Leidensia, reprinted Taipei: Ch'eng Wen Publishing Company, 1973. Huan Kuan's *Yantielun* states that the price of a lacquer cup was three times the price of a similar bronze one. The making of lacquerware is a painstaking process, demanding of time, skilled labour and craftsmanship, and the sap of the lacquer tree is relatively rare, especially in Northern China, which could explain the high price.
2 Prince Liu Sheng's and princess Dou Wan's tombs at Mancheng, Hebei province, contained 571 and 426 ceramic pieces among which were 78 and 67 *hu. cf. Mancheng Hanmu faque baogao,* Beijing: WWCBS, 1980, pp. 120, 284.

7. RECLINING DOG

glazed earthenware,
h: 31.0 cm
Han dynasty 206 BC – 220 AD
1995.581

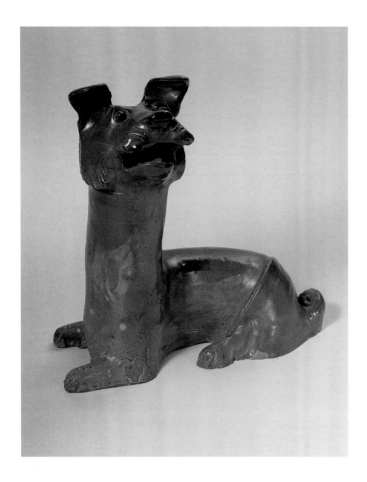

Resting but alert, growling or barking, this not so friendly dog is of a type often encountered in Han graves amongst *mingqi*, funerary objects.

In the everyday world, dogs were used as guardians at the gates of watch towers, houses or granaries; hence their role as sacrificial victims in Bronze Age graves, found in different places, but quite often in the waist pit (*yaokeng*) of Shang or Early Western Zhou tombs where they replaced human sacrificial victims and protected their masters in the underworld. During the Han dynasty, actual canine victims most often gave way to ceramic *mingqi* of dogs.

Like chickens and pigs, dogs were bred in China for their meat as early as the neolithic times,[1] and today are still considered a winter delicacy in the Sinicised world. It is a *yang* (warm) meat in the complex Chinese system of world interpretation, good for the weak and the sick.

A zoomorphic *gui* ewer from tomb M 267 at Sanlihe (Jiaoxian, Shandong province)[2] artistically bears testimony to the dog's presence in the Dawenkou neolithic culture — much as a famous pig-shaped ewer from the Dawenkou site does for pig breeding.[3] Both species brought important protein into the neolithic farmer's diet, at least during ritual ceremonies and sacrifices.

A number of private and public collections in China, Japan and the West keep dog figurines of all dimensions.[4]

1 *Cf.* a famous quotation from the *Shandong yongzhi* (Annals of Shandong Province) by Bertold Laufer in his *Chinese Pottery of the Han Dynasty*, Rutland, Vermont and Tokyo: Charles E. Tuttle Company, 3rd edn 1970, pp. 267–268: 'There are various kinds of dogs. There are the barking dogs with short muzzle, excellent watchers. There are hunting dogs with long muzzle and thin legs, excellent hunters; There are the edible dogs with fat body, which are served as food, and reared in large numbers …'
2 *Cf. Jiaoxian Sanlihe*, Beijing: WWCBS, 1988, pl. 28, illus. 2.
3 *Cf.* Shandong Provincial Bureau for Cultural Relics and Qinan City Museum, *Dawenkou*, Beijing: WWCBS, 1974, pl. 88.
4 The Guimet museum acquired in 1991 a grey earthenware dog in the same position and of similar dimension and artistic quality, *cf.* J.-P. Desroches, *Chine, Des Chevaux et des hommes*, Paris: RMN, 1995, p. 69.

8. SITTING DOG

earthenware
h: 55.5 cm
Han dynasty 206 BC – 220 AD
1995.585

This fierce looking dog appears to be a mastiff,[1] a type bred in China since the Bronze Age. As is well attested in western provinces like Shaanxi and Sichuan, such dogs are still often used by sheep and cattle breeders in the peripheral provinces and autonomous regions of the Peoples Republic of China.

Strong and stout, the dog is obviously well nourished. With his short muzzle and alert ears, panting and ready to move, he could be an excellent guardian or an attack dog. His anatomy is very different from the thin elongated body of hunting dogs, well known from relief representations on the walls of funerary chambers in Northern China.

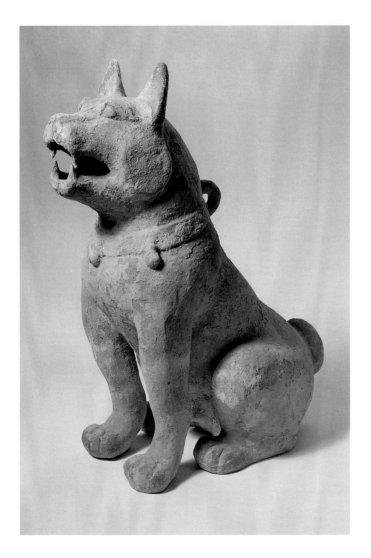

This large and very realistic figurine reflects the pride in which the master of the tomb held his precious beast — shown wearing a luxurious collar of leather fitted with bronze nails, bells and attach ring.[2]

Partially moulded, partially modelled, the figurine attests to the ability of the Chinese craftsmen of the Han to render with anatomical precision and an acute sense of psychological observation[3] the defensive and deterrent purpose of this animal weapon at the side of his deceased master's post mortem property and coffin.

When the fashion spread of reproducing in ceramic the commodities of this worldly life in order to cater to the needs of the dead in the underworld, information on the everyday life of the Chinese gentry was laid in place, to become available to future archaeologists, historians and economists. Unworthy of the brush of the contemporary Chinese scholar who wrote about history, politics or poetry, details of material culture provided by such *mingqi*, funerary objects, give us a lively picture of the techniques and items commonly in use in the great empire a few centuries before, and at the beginning of the Christian era.

This figurine could come from almost anywhere in northern or western China. A large standing dog *mingqi* has been excavated from a cliff tomb dating to the late Eastern Han period[4] at Dawanzui (Leshan) in Sichuan province. Another Sichuanese but slighty later cliff tomb at Tujing (Zhongxian county) shows that, during the local Shu Han dynasty, funerary customs from the Han time were carried on in a very similar style.[5] Dogs and horses remained much in favour.

1 They are all said to descend from the *Canis niger*, black Tibetan wolf. *cf.* Bertold Laufer, *Chinese Pottery of the Han Dynasty*, Rutland, Vermont and Tokyo: Charles E. Tuttle Company, 1970, p. 248 *et seq*. The Chinese mastiffs belong to the *Canis molossus tibetanus* type.
2 Jacques Polain, a passionate collector of Chinese art, has donated to the Guimet museum his collection of *mingqi*, among which is a figurine of a walking mastiff (54 x 54 cm) with a harness-like collar. *cf. Passion for Asia*, Louvain-la-neuve: Editions Duculot 1992, pl. 3, and J.-P. Desroches, *Chine, Des Chevaux et des hommes*, Paris: RMN, p. 71.
3 The Tsui dog is much less stylised than the Polain piece from the Guimet, see *supra*, note 2. Both are beautiful in their own style.
4 *Cf.* KG, 1991/1, pl. 5, illus. 1.
5 *Cf.* WW, 1985/7, p. 88, fig. 89.

9. SADDLED HORSE

grey earthenware with traces of polychromy
h: 84.0 cm
Eastern Han dynasty 25 – 220
1994.291

With braided tail raised and ears alert, the stance of this tall, whinnying stallion suggests a sudden halt. The head is quite stylised, with short triangular ears, protruding eyes, strange round nostrils, and a well-trimmed mane. The mouth, widely open, displays regular rows of teeth through curled lips. The four legs are straight and well formed. The chest shows off bulging muscles, the hindquarter is round, the belly looks supple and full of life. A small detached saddle remains on the horse's back. Very likely the other harness parts were painted on the body, as is common on such horse figurines.

Horses were used in the Bronze Age to draw war chariots or grand carriages,[1] but the mounting of horses[2] in China proper[3] started only during the Spring and Autumn period — by aristocrats, and probably due to the influence of the Steppic peoples to their western side. The terracotta army of Qin Shihuangdi, First Emperor of China (r. 221–207 BC), buried in annex pits around his mausoleum at Lintong (Shaanxi province) comprised some good and beautiful but quite heavy horses.[4] Two half-sized luxury chariots (gilded bronze), unearthed in another pit and currently kept in Shaanxi, were drawn by a set of four strong and stocky ponies, less rapid than the horses of nomadic tribes.[5]

Because several of the Steppic peoples, amongst which the Xiongnu (possibly ancestors of the Huns) constituted an unbearable threat to the Chinese empire, Han Wudi (140–86 BC) ordered the purchase of *tianma*, 'celestial horses', from the Wusun kingdom in Ferghana, in order to improve the local breeds and to build up a cavalry able to fight the Xiongnu riders. The beautiful gilded bronze stallion brought to light in the vicinity of Maoling, the tomb of young general Huo Qubing , was perhaps the representation of a well-liked palfrey cross bred with the newly imported 'celestial' horse.

Han high-ranking civil servants and military officers were often buried with large quantities of horse figurines. Even some affluent provincial gentry ordered beautifully crafted earthenware or sometimes bronze horses.[6] The horse *mingqi* lost their initial military connotations to become, as other funerary objects, testimony to the social distinction of the grave owner, entitled by rank or function to possess a carriage.

Sichuan bricks, such as one from Xindu county or one from Peng county,[7] beautifully depict horses, carriages and drivers.

Sichuan province Eastern Han tombs have yielded remarkable large earthenware horse *mingqi*, very different in type and style from those unearthed in the capital area in Shaanxi province, where they are smaller and with heads reminiscent of the gilded bronze Maoling piece.[8] A one-metre high standing horse from a cliff tomb at Dawanzui (Sichuan)[9] shows fine and more realistic modelling of the head. Like the Tsui horse, it was probably originally fitted with a saddle, since the curve of the back is more concave than the backs of most other known pottery and bronze horses. The Chengdu prancing horse has an earthy character and was probably drawing a carriage.[10] The horse from the Shu Han cliff tomb 5 at Tujing (Sichuan)[11] was installed with a carriage but shows much less craftsmanship and a very different style.

In Western public collections, the two pieces from the Polain donation in the Guimet museum in Paris can be counted amongst the finest from Sichuan. The National Gallery of Australia's horse probably comes from Sichuan as well, and its proposed date would be late Eastern Han period, at the end of the second or beginning of the third century AD.

1 Rulers and aristocrats of the Shang and Zhou times had their war chariots, their horses, and often their drivers, buried in specially built pits in the vicinity of their tombs.
2 Peripheric peoples and tribes to the west and south of China had been mounting horses for centuries, as is well known by texts and archaeological evidence.
3 The term *cheng ma* (mount a horse) is recorded in an entry for the Twenty-fifth year of Duke Zhao of Lu (ruled 541–510 BC), *cf.* Sun Ji, 'Tangdai de maju yu mashi', WW, 1981/10, p. 88, note 1.
4 *Cf. Qin Shihuangdi binmayong keng yihao keng faque baogao,* Beijing: WWCBS, 1988, vol. 2, pp. 152–158.
5 *Cf. Xi'an, Legacies of Ancient Chinese Civilization,* Beijing: Morning Glory Publishers, 1992, pp. 90–91.
6 *Cf.* M. Girard-Geslan, 'An exceptional horse at the Musée Guimet', *Orientations,* Hong Kong, August 1993, pp. 37–39.
7 *Cf.* Gao Wen, *Sichuan Handai huaxiang zhuan,* Shanghai: Renmin meishu CBS, 1987, pls 88, 89.
8 For example at Liangjiawan, in Xianyang, or in the kiln vestiges of Chang'an, *cf.* KG, 1991/1, fig. 8, p. 21.
9 *Cf. ibid.,* pl. 5 illus. 5.
10 See Wang Ziyun, *Zhongguo diaosu yishi shi,* Beijing: Renmin meishu CBS, 1988, vol. 2, pl. 146.
11 *Cf.* KG, 1985/7, fig. 11.

mythology, are interpreted as Taoist; others can be identified as Buddhist because of the presence of Buddhist effigies amongst their decorative motifs.[16] There are several known granary jars bearing Buddhist effigies alongside traditional Chinese religious figures of immortals.[17]

The jar in the National Gallery of Australia is stylistically and iconographically closely related to a piece from tomb 3 at Tianzigang, and to the Jintan jar.[18] As such it may be dated to the late Three Kingdoms period or the early Western Jin dynasty, between 265 and 300. It was clearly made in one of the provinces in the lower Yangzi basin, Zhejiang or Jiangsu, which later were great producers of Yue celadons.

1 'Granary jars', for instance by the staff of the Shanghai Museum, in R.-Y. Lefebvre d'Argencé (ed.), *Treasures from the Shanghai Museum, 6,000 Years of Chinese Art*, San Francisco, Washington DC: The Asian Art Museum of San Francisco, 1984, p. 157, or by Cheng Yisheng, in 'Zhejiang Anjigang Han Jinmu', WW, 1995/6, p. 36, figs 19, 20.

2 'Bottle of the soul', *cf.* 'Jiangsu Jiangningxian Zhangjiashan Xijin mu', KG, 1985/10, p. 909.

3 'Spirit pavilion bottle', *cf.* Mino Yutaka *et al., Masterpieces of Chinese Arts from the Art Institute of Chicago* (in Japanese), Osaka: Museum of Oriental Ceramics, 1989, p. 55, pl. 43.

4 *Cf.* V. Segalen, *The Great Statuary of China*, Chicago: The University of Chicago Press, 1978, p. 52 and pl. 6.

5 A piece kept at the Zhenjiang city museum and reproduced *in Zhongguo taoci. Yueyao*, Shanghai: Shanghai renmin meishu CBS, 1983, pl. 26, *cf. infra* note 16, bears two deers which kept their antlers. It has to be remembered that the deer is a psychopomp animal, which makes sense on such a funerary jar.

6 Linked by three, four, five or more (up to eight) jars of equal or different size, such complex ceramic pieces (the purpose of which still remains largely unknown beside their role as *mingqi*) already appear in Guangzhou tombs from the early Western Han period, see *Guangzhou Han mu*, Beijing: WWCBS, 1981, vol. 2, pls 14, 16, 54, 57. For a short history of the shape, see Zhang Heng, KG, 1991/3, p. 215. For striking evidence of the evolution, see 'Wu, Dongjin, Nanchao de wenhua ji qi dui Haidong de yingxiang', KG, 1984/6, pl. 5 illus. 6 and p. 570, fig. 9 illus. 2, a rather simple piece. See also, 'Zhejiang Jinhua Gufang Liuchao mu', KG, 1984/9, pl. 5 illus. 5, 6 and p. 817, a more complex piece that can be dated to the Sanguo (Three Kingdoms period).

7 A late Eastern Han proto-celadon *wulianguan* has been excavated from a tomb at a hill foot in Huangyan county in Zhejiang province. Of a strange bulging shape and three layers, it already bears human, animal and plant figurines, and birds ready to feed from the minature jar. The worm-like creatures heading towards the holes are here identified as silkworms because of the presence of mulberry leaf motifs. It was probably made in the neighbouring kilns of Wuzhou in Zhejiang. *cf.* WW, 1988/8, pl. 7 illus 2, and pp. 95–96. Another good transition piece, categorised as *wulianguan*, see in *Zhongguo taoci: Yueyao* (1983), pl. 21, excavated at Shangyu in Zhejiang province, dates back to the Wu dynasty but is actually already a *hunping*, with the birds, the kneeling small figurines and the chthonian creature heading towards the hole.

8 Long kiln built along a hill slope, already common in the southern part of the country during the Three Kingdoms period.

9 For instance the Xigang (in Nanjing) Western Jin tomb, *cf.* WW, 1976/3, fig. 9, p. 58, or the Tianzigang Han tomb, in Anji, Zhejiang province, see *supra* note 1.

10 Excellent photograph in *Zhongguo meishu quanji*, Shanghai: Shanghai meishi quanji, 1988, vol. 1, pl. 181.

11 See *Zhongguo taoci: Yueyao* (1983), pl. 21, Wu period (222–280); pl. 26, Wu period from Jintan county (Jiangsu province); pl. 36, Western Jin (265–316) from Pingyang county (Zhejiang); pl. 57, Western Jin from Shangyu county (Zhejiang); pl. 63, Western Jin from Wu county in Jiangsu; pl. 96, Eastern Jin (317–420) from Sushan county (Zhejiang).

12 Which ought to be researched by confronting archaeological data with religious or other texts.

13 As stated on an inscription on a piece excavated in June 1987 from a Western Jin tomb at Guanshanao, in Shaoxing, Zhejiang province: '*Chu Shining yong ci maizang yi zisun zuo shi gao qian zhong wuji*', which can be translated: 'Out of Shining, use this burial [piece] so that sons and grandsons be transfered [promoted as civil servants] in numbers without limit', *cf.* WW, 1991/6, pp. 55–58.

14 As depicted on all kinds of funerary objects and on tomb wall reliefs, as early as during the Western Han dynasty.

15 On several comparable jars these little characters are merely musicians or dancers. Here their coarse aspect may imply that they belong to the underworld. On a Western Jin proto-celadon Yue lamp from a tomb in Xiangyu county, *cf. Zhongguo taoci: Yueyao* (1983), p. 43, such male characters appear alongside female counterparts, with their genitalia exposed. That may indicate a role in the perpetuation of life, either on earth for the family blessed with sons and grandsons, or in the underworld for the deceased himself. Guardians such as on the National Gallery of Australia's piece would symbolically protect the fertility and the fecundity of the family land and women, called for by the object itself.

16 As early as during the Sanguo (Three Kingdoms period), as shown by a *gucang* jar excavated from a tomb on the pottery factory ground at Wuyi in Zhejiang, adorned with three small Buddha figurines sitting on a lotus throne, *cf.* KG, 1981/4, p. 378. For another example: on the Chicago piece, *cf.* Mino Yutaka *et al., Masterpieces of Chinese Art from the Art Institute of Chicago* (1989), p. 137, entry 43. The complex Jintan piece bears a row of 5 applied moulded Buddha images between winged quadrupeds under a row of earthly animals and above a row of aquatic creatures.

17 See the Western Jin dynasty jar from Zhangjiashan at Jiangning, *cf.* KG, 1985/10, p. 909, and pl. 7 illus. 1, 2, on which, according to the report, two series (of 13 and 12) little statues of Buddha adorn the upper part of the vessel, whereas immortals riding dragons adorn the shoulder of the vessel.

18 *Cf. supra* notes 11,16.

12. SADDLED HORSE

earthenware, partially glazed, partially painted
h: 35.0 cm
Late Sui or early Tang dynasty 1st half of 7th century
1995.598

A mingqi, funerary object, this strong yet elegant horse stands firmly on its four straight legs[1] which rest on a rectangular plaque, giving the figurine stability. The head, looking down and slightly bent towards the left, is crowned by a neatly trimmed short mane cut in a triangular shape on the forehead. The tail is long and hangs low.[2] Modelled in relief, the saddle (an)[3] is set on a saddlecloth (jian)[4] spread on the horse's back; attached below the border of the saddle, on each side are large pads scored to imitate fur. Long red drapery (the anfu), looking like a fine wool or silk blanket is thrown over the saddle[5] and hangs low on each side, gathered by a leather strap.

The whole figurine is covered with a thin homogeneous amber glaze. The blanket over the saddle is painted in red overglaze, the pads of fur are incised and bear traces of overglaze green paint. No other traces of paint, for stirrups or straps, remain on the glazed surface, although such descriptive elements were probably present when the figurine was put in the tomb. The horse's beautiful eyes are painted in black for the apple, in brown for the iris, and pink for the cornea.

The policy of importing better breeds of horses from Central Asia was carried on by Chinese rulers long after the Han initiated it. The Tang inherited from their Sui predecessors horses that formed the core of the official stables. Although horses were absolutely necessary to the defence and external policy of the Chinese empire,[6] they were not only used for war, they played an important part in court life in the parades and ceremonies of the emperors. Some horses were taught to dance in order to perform at imperial banquets and festivals.[7] In the Tang emperor's stables there were 400 of these specially trained animals. Horsemanship became a trait of the aristocracy, who used their horses to travel, who loved them and enjoyed them during everyday life, for family outings[8] and lively polo games.[9]

Alongside human figurines of attendants, musicians and dancers, horse mingqi were amongst the favourite grave goods of Sui and Tang aristocrats. At the beginning of the Tang dynasty, before restrictions were imposed upon funerals considered excessively lavish, horse mingqi were paraded in the funerary cortege and could be seen, from the third cart on, in the full brightness of their colours.

They were arranged, along with fantastic guardian figures, in niches (xiaokan)[10] set in the walls on each side of the long descending corridor that gave access to the domed funerary chamber,[11] where the deceased was laid to rest in a coffin often made of dark stone and beautifully decorated.[12]

Moulded in separate parts, the figurines were produced in workshops that specialised in grave goods. Other kilns produced toys and objects for everyday life. Figurines such as this horse were made in huge series, respecting standards of size and type, in order to accommodate special rituals. This particular piece shows that the potter had a real knowledge of horses — the volumes (although stylised) and the proportions are correct and harmonious. And he was a fine observer of horses' expressions — this horse has a delicately modelled head, with ears pricked and a very attentive gaze.

Close in style to one of Zhang Shigui's horse mingqi, this Tsui piece can be reasonably dated to the end of the Sui dynasty or the beginning of the Tang, since Zhang was active at the end of the Sui and under Tang Taizong (627–649). He was considered close enough to this sovereign to deserve a burial on the Zhaoling grounds.[13] Maybe the National Gallery of Australia's horse belonged to a man in a comparable position.

1 Another type of famous Tang horse figurine is the prancing horse.
2 Most horses have very short braided tails, like the Tsui sancai, 'three colour' horse in this collection (catalogue no. 13). Several examples of horses with long tails and bearing their head in the same manner as the Tsui piece have been excavated from the tomb of Zhang Shigui, a high ranking official buried in the vicinity of Tang Taizong emperor's mausoleum (the Zhaoling), at Liquan, in Shaanxi province. cf. KG, 1978/3, p. 172, fig. 4 llus 9, 10, 11, 12, with riders; the horse represented, p. 174, fig. 5 illus 3, not mounted, seems to be quite close to the Tsui piece with its red saddle and under saddle jian (cushion).
3 For the Chinese terminology of horse harnesses and ornaments see Sun Ji, 'Tangdai de maju yu mashi', WW, 1981/10, p. 88, fig. 13.
4 Felt or wool, it is impossible to assess.
5 Pommel and cantle included.
6 As E.H. Schafer puts it in The Golden Peaches of Samarkand, Los Angeles and London: University of California Press, 1963, p. 58: 'The doctrine of the final dependence of the state upon a huge number of war horses is plainly pronounced in the Book of T'ang ...' As explained at length by J. Gernet in Le Monde chinois, Paris: Armand Colin, 1972, pp. 218–219, the Tang dynasty first owned only 5,000 horses, 3,000 taken from the Sui to the West of Chang'an, 2,000 from the Turks in Gansu. State stables were established, and by the mid-7th century the Tang were keeping 700,000 horses grazing in Shaanxi and Gansu; private ownership of horses was flourishing as well in Shaanxi and Shanxi provinces.

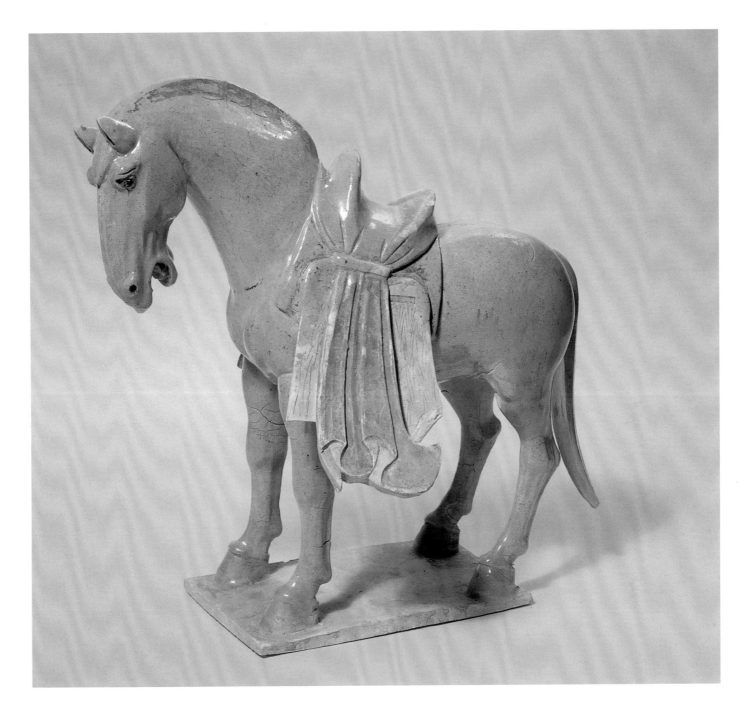

7 Some were even taught acrobatic tricks, as shown by the horse represented on a silver flask from the Hejiacun hoard. Zheng Chuhai relates, in his *Miscellaneous Notes on Minghuang*, that the emperor kept dancing horses that would perform for him on his birthday, starting to caper as soon as the musicians appeared, then crouching on the ground, cup in mouth, to greet the emperor with it. The silver flask belonged to an imperial prince who had it buried with other silver and gold precious objects from his household before fleeing from the capital during a period of political troubles. *cf. Wenhua dageming qijian chutu wenwu*, Beijing: WWCBS, 1973, p. 49.

8 See for instance a famous painting by Zhang Xuan, *Spring painting of the Yu kingdom lady's outing*, in *Zhongguo lidai fushi*, Shanghai: Xuelin CBS, 1984, pl. 226, p. 141, and numerous figurines of riding ladies.

9 Introduced from Persia, through Serindia, the polo game was practised by men and women of the aristocracy. It is the only period in the history of China when aristocrats and intellectuals did not despise physical activities. See the two polo player figurines in the Tsui gift (catalogue nos 21, 22).

10 Some of Zhang Shigui's tomb horse figurines were put with different figurines in the first niche to the east, or the second niche to the east, and some together in the second niche to the west. *cf.* WW, 1978/3, p. 168.

11 For a good map of a typical Tang aristocratic tomb, see *ibid.*, p. 169.

12 Tang princess Yongtai's tomb, famous for its mural paintings of remarkable quality, can still be visited in the Tang mausoleums area in the Xi'an region of Shaanxi province. Not far from the entrance, small chambers were built to store the earthenware *mingqi*. The Tang capital, like the Western Han's, was Chang'an in the vicinity of today's Xi'an.

13 See WW, 1978/3, pp. 176–178. The Zhaoling funeral park is a huge and magnificent area, where the weight of history and a superior civilisation makes itself felt.

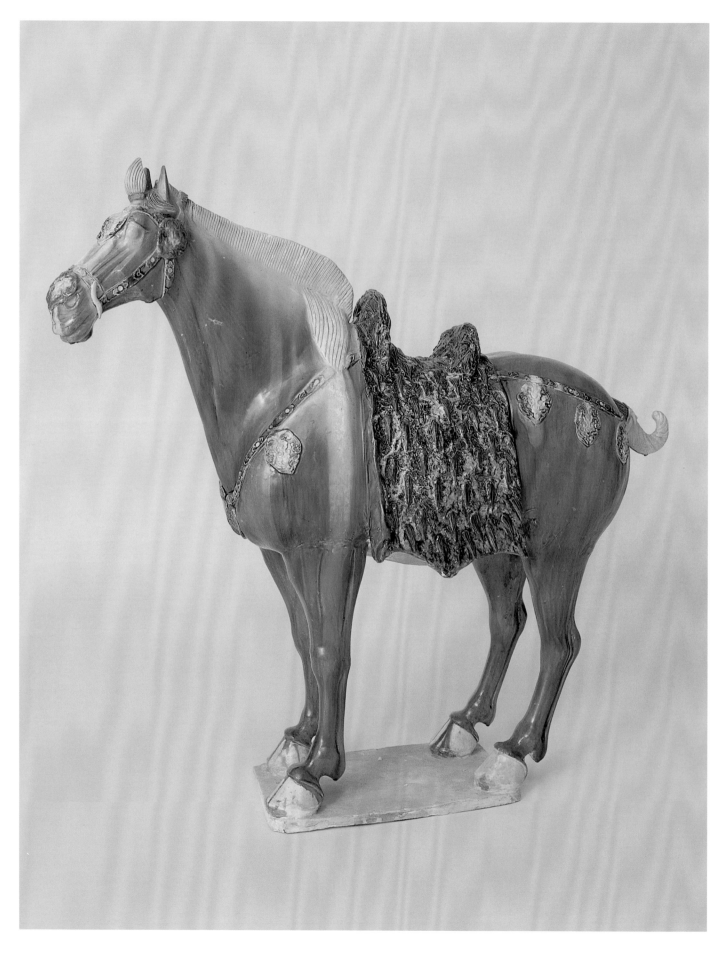

13. STANDING HORSE

earthenware with *sancai* 'three colour' glaze
h: 73.7 cm
Tang dynasty late 7th or early 8th century
1995.587

Rather tall and fully harnessed, the horse stands firmly but without stiffness on a small rectangular plaque. With its ears pricked, its eyes gazing calmly towards the front, its short, tightly braided tail curling up, this beautiful parade mount seems to be waiting for its rider. Its mane is short and well trimmed; a tuft of hair is gathered to form a forelock between the ears, and two side curls are carefully combed around the base of the ears. A long tuft of the mane is allowed its full length, hanging in front of the saddle.

The attire is entirely modelled in relief, so artistically that all parts seem to be really made of leather and bronze or gold. An oval chamfrain pendant (*danglu*) hangs from the head-stall (*luo*) on the frontal bone; and a round ornament hangs from the noseband. The place where the bridle, the headstall and lower headstall bands (*yandai*) meet is covered with a delicately carved roundel. The breast trap (*panxiong*) and the crupper (*fu*) are adorned with moulded oval pendants (*xingye*) — which on a real horse would obviously be of precious stamped metal. All bands and straps bear metallic decorations mainly of elongated rosettes. The saddle — pommel (*qianqiao*) and cantle (*houqiao*) included — is covered with a long luxurious fur or wool rug of the *zhangni* type,[1] which also covers the flanks, as on one of the horses uncovered in a Tang tomb at Yichuan in Henan province.[2]

Far from the indigenous Mongolian tarpan pony, this horse shows the input into the Chinese stock of Arab blood and other Western breeds.

Such a beautiful tall figurine compares well with a piece of similar height and quality kept in the Cleveland Museum of Art.[3] A very good-looking *sancai* horse of comparable dimension (h: 79.5 cm) was excavated from the mausoleum of heir to the throne (Taizi) Li Zhongrun (682–701); it bears imperial attributes, the *sanhua* or three flowers (three tufts cut in the mane),[4] which even outside an archaeological context would have been an important clue for identification of the deceased. Although maybe not of such a prestigious origin, because of the lack of *sanhua*, the National Gallery of Australia's horse necessarily comes from an affluent aristocratic tomb, possibly of a defunct belonging to the imperial entourage, thus from the Xi'an region in Shaanxi province.

1 Here, very luxurious, which is an indication of the deceased's rank.
2 *Cf.* KG, 1985/5, pl. 8 illus. 1 and p. 459.
3 *Handbook of the Cleveland Museum of Art*, Cleveland: Cleveland Museum of Art, 1978, p. 331.
4 *Cf. Shaanxisheng bowuguan*, Beijing: WWCBS, 1990, pl. 65. It bears also a *zhangni* type of rug. A smaller horse with *sanhua* has been excavated in Xi'an in 1957, *cf.* R. Ciarla *et al., Cina a Venezia, From the Han to Marco Polo, China in Venice*, Milan: Edizioni Electra, 1986, p. 92, p.184.

14. CAMEL

earthenware with *sancai* 'three colour' glaze
h: 54.6 cm
Tang dynasty 8th century
1995.584

Crossing the Central Asian deserts with foreign merchants along the silk route, the camel was known in China well before the Han dynasty.[1] But it is only during the Tang dynasty that camel figurines became almost a compulsory item amongst *mingqi*, grave goods, for the high nobility of the time.[2] Once more the empire had expanded widely to the west and camels were much sought after for military and trade purposes; they even joined hunting outings.[3] Imported in large numbers, camels also could be diplomatic gifts or war booty. The Chinese simply could not do without them. Like horses, they were publicly and privately owned[4] and kept grazing in Shaanxi and Gansu. Most herdsmen were barbarians.

Amongst the *camelidae*, the *camelus bactrianus*, present in Asia and famous for its two humps,[5] is able to last seven days without drinking. Thus it is the most appropriate vehicle to cross the Xinjiang desert and carry heavy loads.[6] It was closely associated with many exotic imports that filled the markets of the Tang capital with precious goods and west Asian fragrances.[7]

Chang'an was the end of the western part of the silk route, which leads to the eastern shores of the Mediterranean Sea, and the beginning of the eastern part which, through Korea, leads to Japan. Along this route pilgrims, religions,[8] ideas, decorative motifs and architectural conceptions[9] travelled from one end of the Eurasian continent to the other, until the political conditions prevailing during the twentieth century reduced considerably the crossing of borders by caravans.[10]

This fine camel stands firmly on a rectangular plaque, raising its head and roaring. Its two humps are slightly bent, the fat in them having been partially consumed during the journey. The beast is not saddled but simply bears an oval rug bordered with fringes and pierced to allow passage for the humps.

The piece bears a *sancai,* 'three colour' glaze. The camel's body is of a warm caramel colour with beige areas under the long neck and on the humps. The glaze has peeled off the front hoofs and the plaque, showing the kaolinic clay body reminiscent of the Gongxian workshops in Henan. The rug bears round motifs painted in reserve with the use of wax — as in the textile dying process generally known under the Indonesian name of *batik*. Interestingly enough, the *batik* technique was used on silk in Tang China.

Although built in parts, the camel is not too stereotyped. There is realism in the treatment of the volumes and anatomical structure, and in the fine psychological observation of this stubborn animal, familiar to the potter due to the huge government herds and the foreign merchants' caravans.

Quite close to two *sancai* camels excavated in 1991 from tomb 5 at Beiyaocun, in Luoyang, Henan province,[11] and to another pair from a tomb in the western suburb of Xi'an, equipped with the same type of oval rug,[12] the National Gallery of Australia's camel definitely comes from the middle ridges of the Yellow River basin, either from a Shaanxi kiln or a Henan one. Stylistically, it can probably be dated to the first half of the eighth century.

1 The Han used camels in military and trade caravans between their empire and Serindia. A very fine example of a kneeling camel figurine has been excavated from the Eastern Wei tomb of a Ruru nationality princess, at Cixian, in Hebei province. See WW, 1984/4, pl. 1 illus. 3.

2 A lot of these camel *mingqi* have been scattered in collections all around the world, but the most outstanding pieces remain in Chinese public collections, in the National History Museum in Beijing, in the Shaanxi History Museum, in Xi'an; see in the series of books about Chinese museums, *Zhongguo lishi bowuguan*, Beijing: WWCBS, 1981, pls 127, 137, 138, and *Shaanxisheng bowuguan*, Beijing: WWCBS, 1990, pls 58, 80, 81.

3 To carry equipment or food, as shown by a mural painting from the east wall in the passageway of Li Xian's tomb. *cf.* Zhang Hongxiu, *Highlights of the Tang Dynasty Frescoes*, Xi'an: Shaanxi renmin meishu CBS, 1991, p. 99, pl. 105.

4 See *supra*, catalogue no. 12, note 6.

5 Whereas the African camel, the dromedary, has only one hump.

6 See for instance in Xi'an, kept in the Shaanxi History Museum, a beautiful *sancai* camel loaded with two packs and led by its foreign-looking groom.

7 Even today, especially in the Moslem or Hui quarter, the Xi'an cuisine keeps a slightly Indianised flavour, reminding the traveller of the city's position at the crossroads of cultures.

8 Not to be forgotten, left in the shade of better-known Buddhism, the spread of Nestorian Christianity from Sassanid Persia after the 1st–5th century AD, first to the oases cities of Central Asia, and then to the heart of the Tang empire in the Gansu cities and along the Wei River valley to Chang'an, where the Gospels were introduced in 631.

9 Buddhist cave sanctuaries were created in China as early as the 4th century AD, under the rule of the Northern Dynasties, of barbarian origin and influenced by Central Asian modes.

10 Camels remained a familiar view under Beijing's walls at the beginning of the 1950s.

11 M 5 : 35 and M 5 : 36, *cf.* KG, 1992/11, pl. 7 illus. 3, 4, are 55.9 and 53.5cm high, both roaring, one saddled, the other unsaddled. Morphologically, the National Gallery of Australia's piece relates as well to a Yanshi county piece dating to the beginning of the 8th century, *cf.* KG, 1986/11, pl. 7 illus. 4.

12 One (h: 62 cm) has a raised head but keeps its mouth shut. The other (h: 61 cm) is roaring and bears an elaborately decorated saddle, *cf.* WW, 1990/7, p. 44, figs 5 and 6.

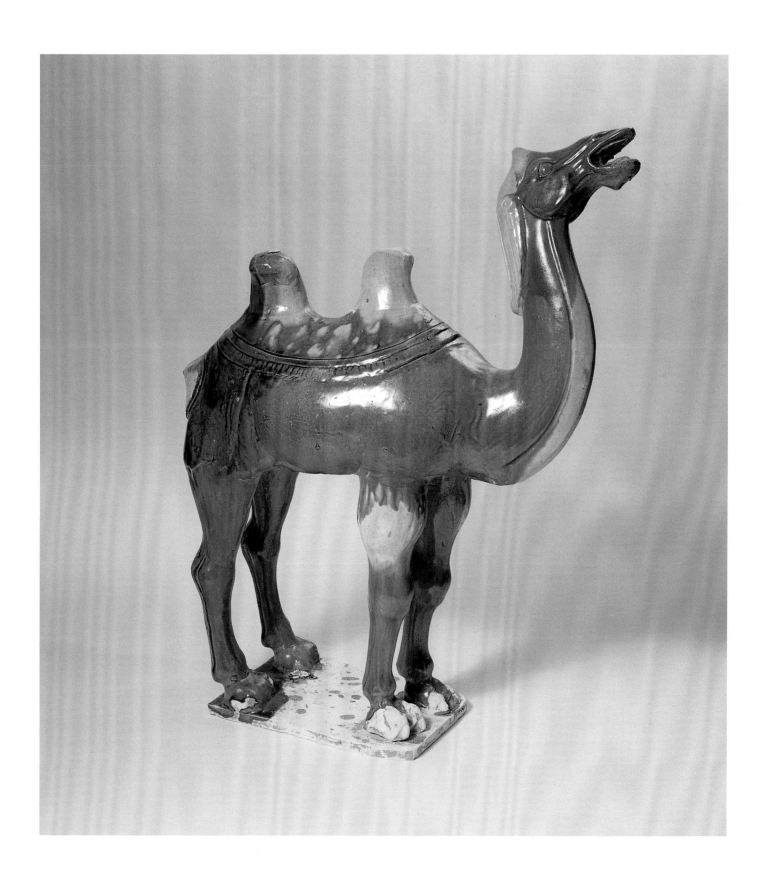

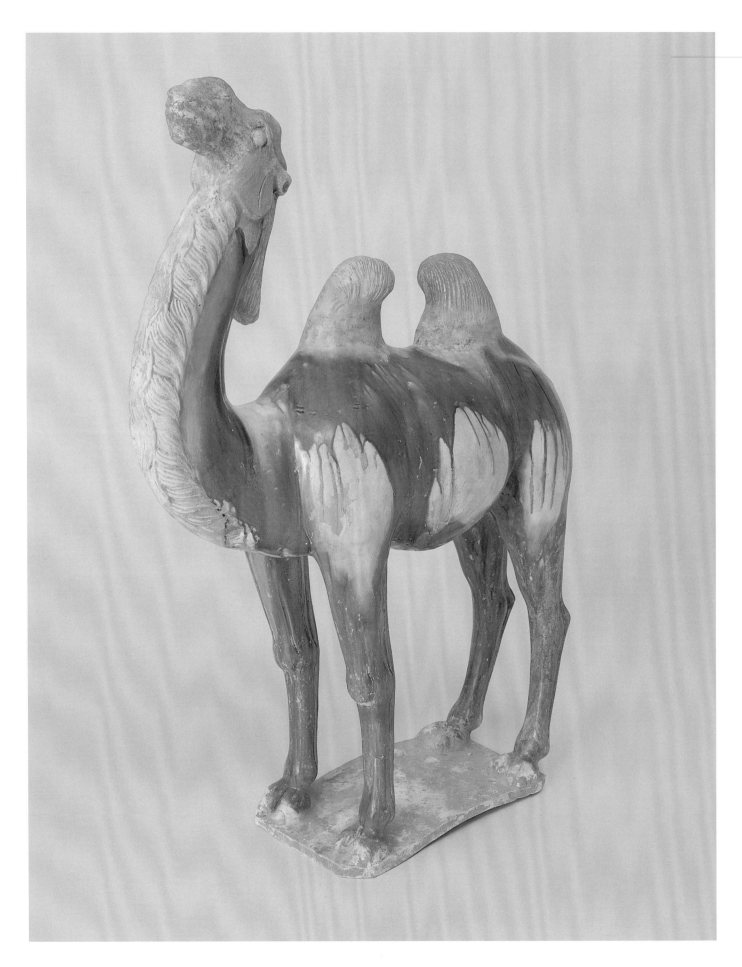

15. CAMEL

glazed earthenware
h: 82.0 cm
Tang dynasty 8th or 9th century
1995.583

This fine monumental piece, standing with head raised and mouth shut, appears about to roar. The details of the long hair on the back of the head, on the neck and on the humps have been incised in the still moist carefully modelled clay. The front legs look different from the other Tsui camel (catalogue no. 14), or the Yanshi county piece in Henan.[1] Those figurines have quite bulbous front legs, whereas this camel has straighter legs, not unlike those of a smaller piece uncovered in 1983 in Linru county, in Henan province.[2]

The beast does not bear a saddle, nor even a rug. No trace of harness is visible. There is a famous crouching camel kept in the Shaanxi provincial museum which, unsaddled, is nevertheless mounted by a foreign looking groom.

The glaze is caramel-brown with long drippings, and a buff colour on the head, the front of the neck, on the humps and the flanks.

Because of its dimensions and its fine quality, the piece in the National Gallery of Australia probably comes from a prince's tomb in the Shaanxi or Henan province. Taken to the underworld by an affluent defunct, it bears testimony to the wide use of camels, bred in public or private stables all over Northern China for both military and trade purposes.

1 See *supra*, catalogue no. 14, note 11.
2 32 cm high, although quite a good example, it is more stereotyped than the National Gallery of Australia's camel (catalogue no. 14), *cf.* KG, 1988/2, pl. 8 illus. 1. The big tomb, without a stele to date it, is considered by Chinese archaeologists to be full Tang. The National Gallery of Victoria keeps a roaring camel (h: 52.5 cm), which has the same type of leg and the same colours. Although a good piece, it does not reach the same quality as this Tsui camel. *cf.* M. A. Pang, *An Album of Chinese Art,* Melbourne: National Gallery of Victoria, 1983, p. 83.

16. FIGURE OF A WOMAN

painted earthenware
h: 45.0 cm
Tang dynasty 8th century
1995.572

Tang emperor Xuanzong (712–756) had a favourite concubine, Yang Guifei (Precious Concubine Yang), with charming plump silhouette and round face — characteristics which, for centuries, have been believed to have launched a new fashion at the capital amongst court ladies and their attendants.[1] Far from the linear, quasi graphic, idealised image of the female body, so appreciated since the remotest past of China, and well represented in Han, Six Dynasties,[2] Sui and even early Tang art, the new fashionable look of the eighth century appears quite puzzling to the unknowing eye, to the point that such figurines are often called 'fat ladies' in Western catalogues.

The Tsui piece is a good example of this rather short-lived fad. Of a height often encountered amongst 'fat lady' figurines, she seems to be aged in her thirties or forties. Her simple hairdo gathers her black hair on top of her head in two horn-like rather flat locks. She turns her head towards the right. Her fine features are delicately modelled. Her long thin nose and her pretty little mouth seem sunken in her lunar face. The fine eyebrows and beautiful slanted eyes are described in black with supple brushstrokes. Her beauty is enhanced by a discreet make-up of vermilion red on her lips and light pink on her cheeks.

The lady wears a simple outfit: a long loose overrobe with round collar is gathered on the hips by a red belt.[3] Her hands, raised as if carrying something, show the sleeves to be of medium size. During the Tang dynasty there were two other types of sleeve: one with a very wide lower part, still encountered in Japanese kimono; the other, fitted and narrow such as today's Chinese *cheong-sam* or *qibao*. The lower part of the robe is slit on the side and reveals the undergarment, which could be a pair of loose trousers or a long skirt. Simple split-toed shoes are visible on her full-sized feet.

Details of folds and gatherings of the fabric are incised. Of the colours that were probably applied on the white slip, none remains visible other than the red of the belt. One could have expected a quite large round decorative motif on the chest and on the back as well as at knee height; but unadorned outfits are also encountered.

This type of costume was fashionable from Central Asia to China during the Tang period. The empire comprised then what is most of today's Xinjiang autonomous region (Chinese Turkestan). Central Asian oases were subjected to a marked Chinese cultural influence and China, strong and self-confident as it was, was happily receiving many foreign fashions from there.

The lack of colour (which may have disappeared, revealing the white slip[4]) does not allow the identification of the textile,[5] nor a guess about the exact social status of the character represented. But since the facial features are perfectly well preserved, one can notice that the woman does not wear the characteristic elaborate make-up of the highest ranking court ladies — no flower on the forehead, no eyebrows in the shape of butterflies, no dots on each side of the mouth, no flowers on the cheeks.[6]

A high ranking aristocratic woman would also have a more complicated hair style, higher and with greater volume.[7] However, this particular lady does not look like a servant — she does not have the typical hair of female horse grooms[8] or female merchants,[9] parted in the middle with one bun on each side of the head. If the figurine were not acquired in a hurry, or left undecorated for some other reason, our lady may be a low or medium ranking aristocrat, perhaps an attendant to a princess,[10] or an ageing concubine out of favour. Her expression has a certain pride and reserve, and her gaze is too high, although not haughty, for her to be very low on the hierarchic ladder of the Tang time.

These figurines were moulded, fired and then painted on a slip after cooling. Like the horses, camels, and other figurines of animals and humans, they were placed in niches bordering the tomb corridors. They were grave goods but, maybe due to the wide diffusion and strength of the Buddhist faith in Tang China, they lack the mystery that surrounded Qin and Han *mingqi* of respectful mourners or dancers.

The National Gallery of Australia's figure, because its style is definitely linked to the fashions of the imperial court, probably comes from the capital area in Shaanxi province. It is actually very close in its dimensions and style to women's figures from the Yang Sixu tomb excavated in Xi'an in 1958.[11]

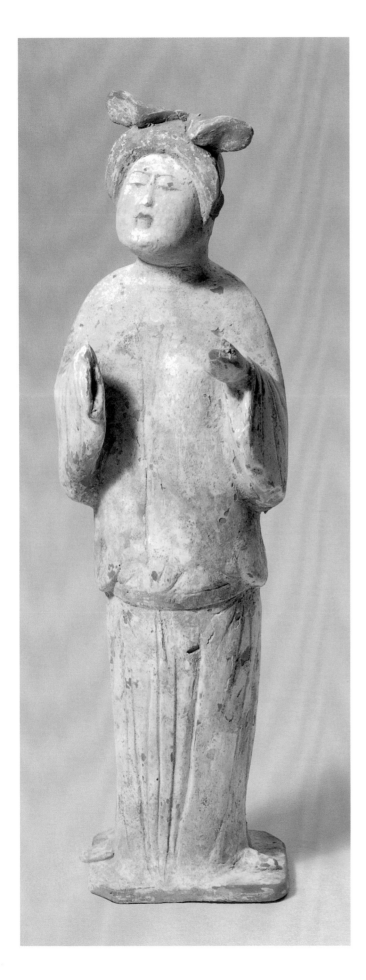

1 Actually plump figurines predating the apparition of Yang Guifei are known from tombs where they are place in a prominent position. None appears after the middle of the 8th century though.

2 In Chinese: Northern and Southern Dynasties. After the fall of the Han dynasty the empire was divided into 'Three Kingdoms'. Then troubles led to further divisions. The second period is known as the 'Six Dynasties' period. A long period of political unity followed after the Sui reunified China.

3 Although simpler, not unlike the costume worn by a helper to a court lady seen on a famous horizontal scroll painted by Zhou Fang, *cf. Zhongguo lidai fushi*, Shanghai: Xuelin, 1984, pl. 241, p. 146. Quite close to the costumes worn by two female attendants standing at the 2nd row on a painting on the south part of the east wall of the back chamber in Li Zhongrun's tomb, at Jianxian, in Shaanxi province, *cf. Murals in the Tomb of Li Zhongrun of the Tang dynasty*, Beijing: WWCBS, 1974, pl. 38.This costume, in the short version, was shared by males and females and was worn by civil servants and palace attendants. The figure of the female clad in male apparel appears often in Tang iconography in tomb mural paintings as well as among *mingqi*. See Sun Ji, 'Tangdai funüde fuzhuang yu huazhuang', WW, 1984/4, fig. 8, p. 63.

4 Like a 'fat lady' from the National Gallery of Victoria, *cf.* M.A. Pang, *An Album of Chinese Art*, Melbourne: National Gallery of Victoria, 1983, p. 77.

5 The art of textiles reached a very high technical and artistic level during the Tang dynasty, as shown by mural paintings and tomb painted and glazed figurines. *Batik* wax dye (*laxie* in Chinese), *ikat* tie dye (*jiaoxie* in Chinese), appliqué, embroideries of many kinds, possibly supplementary weft techniques were known to the Tang weavers. *cf. Xinjiang chutu wenwu*, Beijing: WWCBS, 1975, pls 141–162.

6 *Cf. Zhongguo lidai fushi* (1984), pls 250–255 p. 150, and Sun Ji, 'Tangdai funüde fuzhuang yu huazhuang', WW, 1984/4, figs 12 and 13, p. 66.

7 *Cf. Zhongguo lidai fushi* (1984), pp. 146–147 and 150, for examples of 'fat ladies'. The tall thin elongated court ladies of the early Tang dynasty had still more complicated and spectacular hairdos.

8 See for instance MA 6123 in the Polain donation in the Guimet museum, J.-P. Desroches *et al., La Chine des origines,* Paris: RMN, 1994, p. 151. See *Zhongguo lidai fushi* (1984), p. 141, the top figure on the painting 'Lady of Guo's Spring Promenade'.

9 See H. Brinker and E. Fischer, *Treasures from the Rietberg Museum*, New York: Asia House Gallery, 1980, p. 43.

10 Although much younger looking, an attendant to a court lady is represented on a mural from Li Xian's tomb, with the same hairdo and the same costume, *cf. Zhongguo lidai fushi* (1984), pl. 232, p. 143.

11 Two were on display at an important Chinese exhibition in Venice in 1986, see R. Ciarla *et al., Cina a Venezia, From the Han to Marco Polo, China n Venice*, Milan: Edizione Electra, 1986, pp. 162–163.

17. GUARDIAN FIGURE (*LOKAPALA*)
earthenware with traces of polychromy
h: 56.6 cm
Tang dynasty 618 – 907
1995.597

Guardian figures, *lokapalas* — called *wushi* (military officer)[1] or *zhenmu weishen* (guardian spirit of a tomb) in a voluntarily unreligious, uncommited way,[2] or *tianwang* (heavenly kings) when using a Buddhist vocabulary[3] — protect the tomb. The Buddhist conception and the Chinese tradition merge in these figures. In a Buddhist context, they are the guardians of the world — one for each of the four quarters of the universe — and of the Buddhist faith. They are always present at the first gate pavilion in a temple.

During the Tang dynasty, when Buddhism became unprecedently strong in China, thanks to imperial support (before a terrible crackdown about the middle of the ninth century), figures of *lokapalas* appeared alongside traditional Chinese tomb guardians (*zhenmuyong* or *zhenmushou*), amongst the grave goods installed in the side niches of the entrance corridor to the tombs.

Clad in a military attire, with helmet, breast-plate and high epaulettes, this muscular *lokapala*, with a frightening expression on his exotic looking face,[4] tramples a grotesque devilish dwarf figure[5] resting on a rock-like pedestal.

Originally painted on the slip (the lips are still red), the uniform of this figure must have been as colourful and awe-inspiring as uniforms worn by similar figures treated in *sancai*, 'three colour' glaze. Rich in connotations, both foreign and Buddhist, as well as local and traditional, the main task of the *lokapala* was to scare away evil spirits who may have come to disturb the defunct — hence their position in niches at the entrance to the tomb, and their fantastic and theatrical aspect.

The National Gallery of Australia's *lokapala* is a classical Tang guardian that may have come from any gentleman's tomb in Northern China.

1 *Cf. Quanguo chutu wenwu zhenpin xuan 1976–1984*, Beijing: WWCBS, 1987, pl. 368.
2 *Cf. Zhongguo diaosu yishu shi*, Beijing: Renmin meishu CBS, 1988, vol. 2, pl. 502.
3 *Cf.* KG, 1986/11, pl. 7 illus. 1, or KG, 1991/5, pl. 3 illus. 6.
4 Bulging round eyes and a large face are supposed to be characteristics of western, i.e. Central Asian, peoples.
5 Other *tianwang* trample a bovine figure, *cf.* KG, 1986/11, pl. 7, illus. 1, or KG, 1991/5, pl. 3, illus. 6, or a 'slave girl of Kunlun', *cf.* R. Ciarla *et al.*, *Cina a Venezia, From the Han to Marco Polo, China in Venice,* Milan: Edizione Electra, 1986, pl. 89.

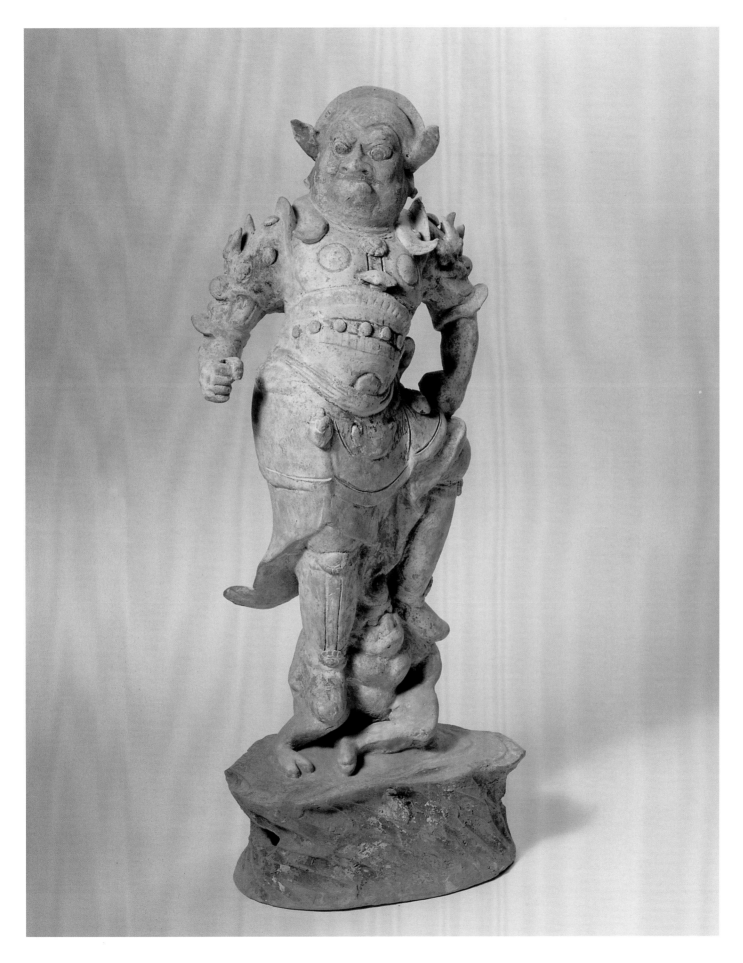

18. RIDING ORCHESTRA, EIGHT MUSICIANS ON HORSEBACK

painted earthenware
h: *c.* 34.8 cm
Tang dynasty 618 – 907
1995.578 A –H

During the Tang dynasty, the music of China, like the other fields of religious and artistic life, received quite a strong influence from Central Asia,[1] which is still perceptible in the Buddhist temple music of today's Xi'an area. A good testimony to this type of cultural exchange is the liking of the time for the theme of riding musicians amongst tomb figurines.

In this band, all the musicians have moustaches and wear the same type of uniform:[2] beige hood, red robe, and red trousers tucked into black boots.[3] There are two drummers, perched on their horses as if riding side-saddle, their flat instrument to their left. Originally holding drumsticks — now missing — they are caught in the middle of a movement. The other musicians play the fife (*dizi*), the flute (*xiao*), the transverse flute (*yue*), and pan-pipes (*paixiao*).[4] One, who has lost his instrument, holds his arms in such a position as to suggest he may have been emphatically playing the harp (*konghou*)[5] — if each hand had not been

pierced with a round hole. These holes could have been fitted with little hammers, as used on a trapezoid horizontal zither; but since no trace of any instrument is visible, either on the horse's neck or on the saddle, the mystery remains.

It would not be surprising if one of the missing instruments had been a mouth organ, several types of which are known to have been played during the Tang time, as shown by the Xi'an camel orchestra,[6] the Su Sixu's tomb mural of *huteng* dance and music,[7] and by one of the carved stone walls of Li Shou's mausoleum.[8]

Although extremely fashionable at the time, it seems that no guitar-lute (*xiaohulei, da hulei,* or *pipa*) was the instrument played by any of these musicians, since none of them has his left hand extended at the level of his waist to hold the neck, nor right hand in a position to hold a plectrum.[9]

The musicians don't have very exotic features, therefore they can be from the Shaanxi or any of the neighbouring western areas.

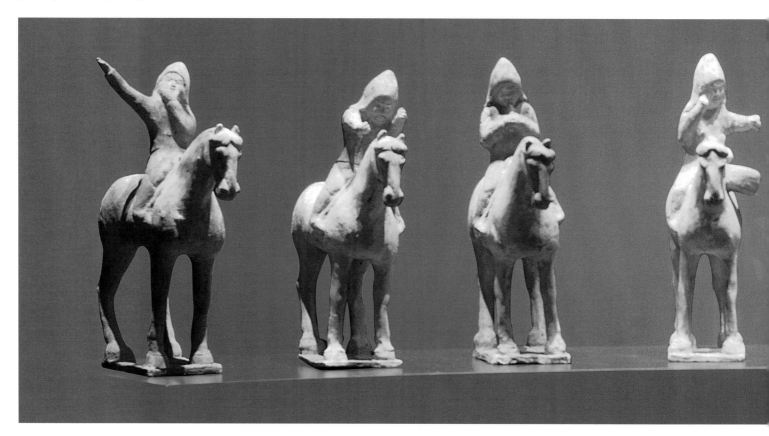

Four of the pieces have kept most of their painted decoration, the pinkish slip and details on the horses; and the riders' faces still display their freely but thoroughly painted features. The other four have lost the pink slip and display the whitish kaolinic body of the figurines. Curiously enough, the costumes and faces of these riders are reasonably clear and keep some colour. It is likely that the two series of objects were kept in the same conditions of humidity, in the same niche, but probably one series was painted with more diluted paint or with less care than the other. Fingerprints of the potter or the painter appear on some of the horses.

Such apparently complete ensembles of riding musicians as the group in the National Gallery of Australia are not often found. One of the most famous groups comes from Dugu Sizhen's tomb, in Xi'an: the five pieces are coated with a *sancai*, or 'three colour' glaze; all instruments but two drums have disappeared.[10]

1 Some instruments were added to the original stock of Chinese instruments known through archaeological excavations. Neolithic time music knew lithophones, drums, flutes and ocarina (*xun*). The Bronze Age music relied heavily on finely-tuned bronze bell chimes of different types, on lithophones, and on different types of drums. Warring States and Han music used wind instruments as well, mainly fife, flute and mouthorgans, and horizontal string instruments such as the *se* or the *zheng* (two different zithers). The much-celebrated Tang music used different types of lutes, and a recently incorporated *hu qin* (western barbarian lute).

2 To accommodate the new lifestyle, in which riding was becoming more and more important, the Chinese costume underwent a simplification and started becoming close to the Kushana costume.

3 It is impossible to know if they were made of felt or of leather, but one has to keep in mind that felt boots were widely worn all over the dry areas of Central Asia. The musicians' costume is similar to the first foreign envoy's costume on a section of Yan Liben's horizontal scroll reproduced in *Zhongguo lidai fushi*, Shanghai: Xuelin, 1984, pp. 126-–127.

4 Already used during the Warring States period, see for instance Zeng hou Yi's grave goods, *cf. Zenghou Yi mu*, Beijing: WWCBS, 1989/2, pl. 6, illus. 6,

5 On the famous camel unearthed in 1959 in a Tang tomb at Zhongbao, in the western suburb of Xi'an, one of the musicians of the band of eight, sitting on a stage installed on the beast's humps, still carries his harp resting along the right side of his body. *Cf. Shaanxisheng bowuguan*, Xi'an: SXBWG, undated, p. 77. The harp seems to have been known already at Han Wudi's court, *cf.* Tang commentary of the *Shiji*, quoted *in Zhongguo yinyue cidian*, Beijing: Institute of Musical Research, Renmin yinyue CBS, 1984, p. 209. A beautiful frescoe from Su Sixu's tomb represents a scene of *huteng* (Western) dance and music. Among the musicians, sitting on a rug or a mat, there is a harpist whose instrument is quite accurately painted, *cf.* Yin Shenping (ed.), *Tang mubihua zhenpin xuancui*, Xi'an: Shaanxi Renmin meishu CBS, 1991, pp. 11, 16, 17.

6 See *ibid.*, note 100.

7 See *ibid.*, note 129, pp. 11, 12, 13.

8 *Cf.* Wang Ziyun, *Zhongguo diaosu yishu shi*, Beijing: Renmin meishi CBS, 1988, vol. 2, pl. 537.

9 *Cf. ibid.*, a male lute player on another camel, p. 188, and a female lute player on a painting reproduced in *Zhongguo yinyue cidian* (1984), col. pl. 17. A lute, quite close to the *pipa*, was known at the end of the Qin and under the Han dynasty, *cf.*, *ibid.*, p. 291.

10 *Cf.* R. Ciarla *et al.*, *Cina a Venezia, From the Han to Marco Polo, China in Venice*, Milan: Edizione Electra, 1986, pp. 173–177, pls 79–84. The Art Gallery of New South Wales keeps a fine *sancai* drummer on horseback, *cf.* J. Menzies, *Asian Collection*, Sydney: Art Gallery of NSW, 1990, p. 25.

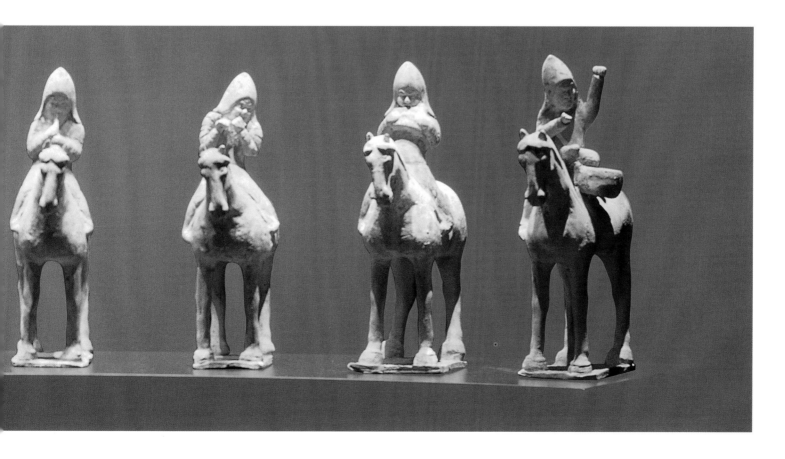

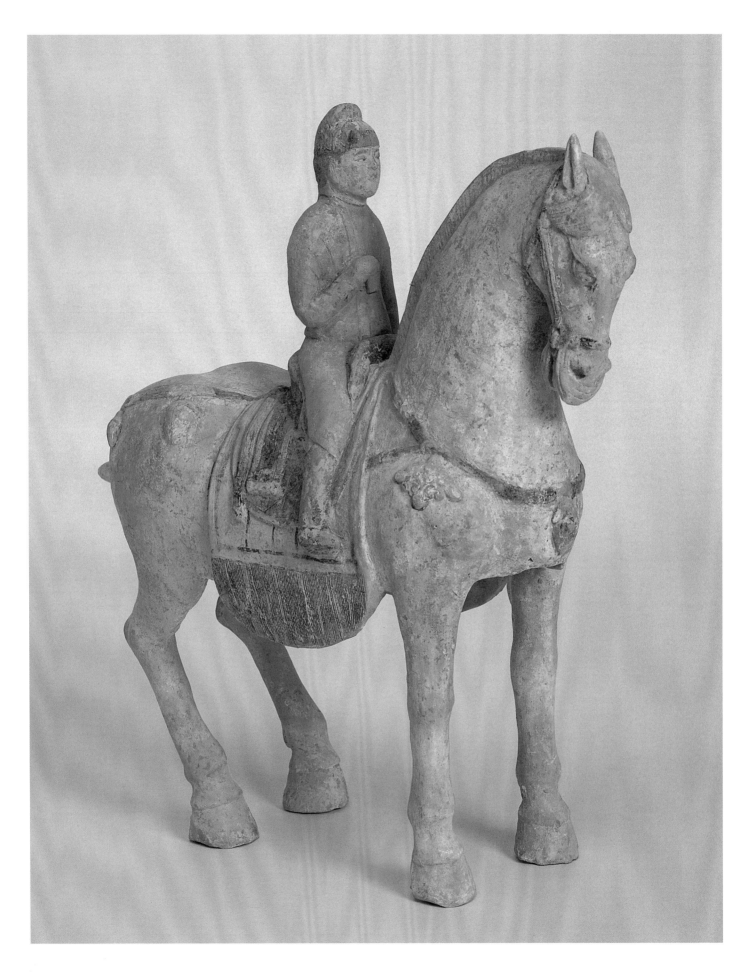

19. HORSE AND RIDER

painted earthenware
h: 55.0 cm
Tang dynasty 618 – 907
1995.592

The ceramic horse and rider is the hallmark of Tang funerary figurines. The love of Tang emperor Taizong (627–649) for the six horses which were his companions during his struggle for the throne led him to have them portrayed in his mausoleum, epitomising the strength of the new relationship of the Chinese aristocrats with their mounts.[1]

Originally used only to draw carts or chariots, and for centuries merely marginally mounted, it was not until several dynasties of barbarian origin ruled over the northern part of the country (Beichao or Northern Dynasties, 4th–6th century) that Chinese horses started being part of the everyday life. A great change occurred thanks to the mixed-blood aristocracy of the Tang empire. These gentlemen then enjoyed the horse as a commodity and stopped thinking of it only in military terms; they adopted more practical clothes from the western countries,[2] even for peaceful leisurely activities, amongst which hunting had a prominent place. Some aristocrats owned these noble animals by the thousands.

This rider, whose features are Chinese, wears a classical Chinese hat,[3] a simple red coat or overrobe, belted at the hips, on loose trousers tucked into knee-high black boots.[4] A very long sleeve covering the left hand is an aristocratic style, not found on grooms.

The standing horse[5] is a powerful palfrey, saddled on two rugs: a long one with flanges hanging low on each side; a shorter oval rug, stabilised by heavy leather straps, at the end of which tassles (maybe leaded) act as counterbalances. The details of the rugs and the saddle, of the different straps and their refined metal decorations, are treated in moulded low relief. They were originally decorated in paint, some of which remains on the pinkish-whitish slip. Sophisticated metal pendants indicate the rider's high position in society and that the horse is not out for a sporting event.

Simply built in separately moulded and fired standardised parts, and without a belly section, the horse nevertheless has a proud aspect, thanks to its good proportions and beautiful head. The ears are turned to the sides as if ready to catch his master's order. The forelock is elegantly parted in the middle, The mane is neatly trimmed at the centre, with a section kept at full length and hanging on the left side. The eyelids are finely modelled and underlined with a supple thin brushstroke.

Although the finish could have been better crafted, and the horse lacks a belly, the size and the detailing probably indicate a reasonably good provenance.

1 Portrayed in sculpture, known as the 'Six Bayards', they were celebrated in poems composed by the emperor himself. The tragic fate of another of the emperor's horses was marked with a musical composition commissioned by Taizong himself.
2 Western regions, for China, start with Xinjiang and Central Asia. See *supra*, catalogue no. 18, note 2. Interestingly, an important change in the Chinese costume occurred during the Warring States period, when trousers were adopted. Contacts with nomadic peoples from the steppes who practised a very efficient and mobile type of war were responsible for the evolution.
3 A cloth hat which was probably starched. Quite close to one seen in Zhou Xibao, *Zhongguo gudai fushi shi*, Beijing: Zhongguo xiju CBS, 1984, fig. 9, p. 185.
4 His costume, like the musicians' costume is similar to the one worn by the first envoy on the section of Yan Liben horizontal scroll reproduced in *Zhongguo lidai fushi*, Shanghai: Xuelin CBS, 1984, pp. 126–127. For the hat, see also *ibid.*, pl. 194, p. 124. This costume is worn by civil servants, security guards and gentlemen out for hunting, as shown on many tomb mural paintings.
5 This horse and its companion are not resting on a rectangular plaque as is most often the case among Tang dynasty *mingqi*.

20. HORSE AND BARBARIAN RIDER

painted earthenware
h: 55.0 cm
Tang dynasty 618 – 907
1995.593

A foreign looking man, maybe of Iranian origin, with a rather high nose, thick moustache and beard, is wearing over a vest the recently imported *huyi* or barbarian costume, which in his case seems appropriate. He has unbuttoned his round collar and has rejected his left sleeve, which is tucked into his belt behind his back.[1] The *huyi* is worn over loose trousers, tucked into black boots. The man's hair is gathered into a bun under a *putou* (headcover).[2] His mount is a strong standing horse which is obviously accustomed to his steady hand.

Since there is a quiver holding several arrows on the right side of the saddle, the man is probably hunting. There is no trace of a bow to be found except, perhaps, in the irregular groove just before the saddle. And there is no trace of a case or a half box[3] — usually figures of hunters carry arrows in what seems to be a lacquered box[4] fixed to their right side,[5] with the bow in its case on their left side.[6]

The animal resting on the man's left thigh, its head on the cantle, looks like a small mammal. It may be recently hunted game or a living animal, a mongoose or a ferret.[7] When departing for a hunt, Tang hunters could carry on their horses all sorts of auxiliary animals, hawks, even leopards.[8]

The horse's harnessing is treated in painted relief. It is simple and, like the horse, is very neat, well looked after by a competent groom. The blond mane is carefully combed, parted in the middle on the forehead, and hanging on the left side of the neck.

The rider seems to be of short stature, almost a dwarf. His feet don't even reach the lower edge of the smaller of the two oval rugs. The light beige larger rug still bears a black painted decoration forming a cartouche edged by a compartmented frame — perhaps indicating embroidered felt or dyed wool, it is impossible to guess the type of fabric. The devices used to stabilise the rugs and saddle are of the same type as those on the horse and rider (catalogue no. 19). The crupper is fixed to a tightly tied short hanging tail. The four hoofs still bear their original black colour.

The foreign horse groom is a classical figure of Tang funerary iconography.[9] But this short foreigner seems to enjoy a better status.

It cannot be established that this horse and rider forms a pair with the previous piece. The two riders do not wear the same type of attire, even if basically the costume is the *huyi*. And horses on a hunting outing do not bear pendants on their bridles, as found on the previous horse. They may, nevertheless, belong to the same series of *mingqi*, their size and style being similar. This piece is in slightly better condition, having kept a little more of the painted decoration

1 This is not often seen. A tall standing Tang horse groom from the Jacob collection in Paris is another rare example of this relaxed attitude. *Cf.* J.-P. Desroches, *Chine, Des chevaux et des hommes*, Paris: RMN, 1995, p. 119, pl. 40.
2 Several models existed. *Cf.* Zhou Xibao, *Zhongguo gudai fushi shi*, Beijing: Zhongguo xiju CBS, 1984, figs 14 – 24.
3 A famous stone carving, from a Tang Kaiyuan era tomb, excavated in the southern suburb of Xi'an in Shaanxi province, and kept in the Chinese Museum of History, represents a man carrying, amongst other things, a retroflex bow in its finely decorated half case, *cf. ibid.*, p. 188, fig. 17, and for a remarkable photograph, see *Zhongguo lishi bowuguan*, Beijing: WWCBS, 1981, pl. 148.
4 As shown by a mural in the fifth airshaft of Arshinar's tomb, representing a waiting man carrying a bowcase and an arrow quiver, *cf.* Zhang Hongxiu, *Highlights of the Tang Dynasty Frescoes*, Xi'an: Shaanxi renmin meishi CBS, 1991, p. 82, pl. 88, and for a remarkable photograph see *Zhongguo lishi bowuguan* (1981), pl. 148.
5 *Ibid.*, p. 101, pls 108, 109.
6 The bows of three gentlemen appear behind their backs on the left side, *ibid.*, pl. 108. For a view of hunters shooting, see a mural from the north side of the east wall in the passageway of Li Shou's tomb, *ibid.*, p. 22, pl. 1. They are seen galloping towards the left and shooting at small black boars, the top of one rider's quiver, with a bundle of arrows, is visible on the right side of his horse.
7 *Cf.* E.H. Schafer, *The Golden Peaches of Samarkand*, Los Angeles/London: University of California Press, 1963, p. 91.
8 *Cf.* Yin Shenping (ed.), *Tang mubihua zhenpin xuancui*, Xi'an: Shaanxi Renmin meishu CBS, 1991, p. 44.
9 See for instance, KG, 1984/10, pl. 5, illus 1, 2, for two such painted figurines from tomb 5, at Yanshi, Henan province and numerous mural paintings.

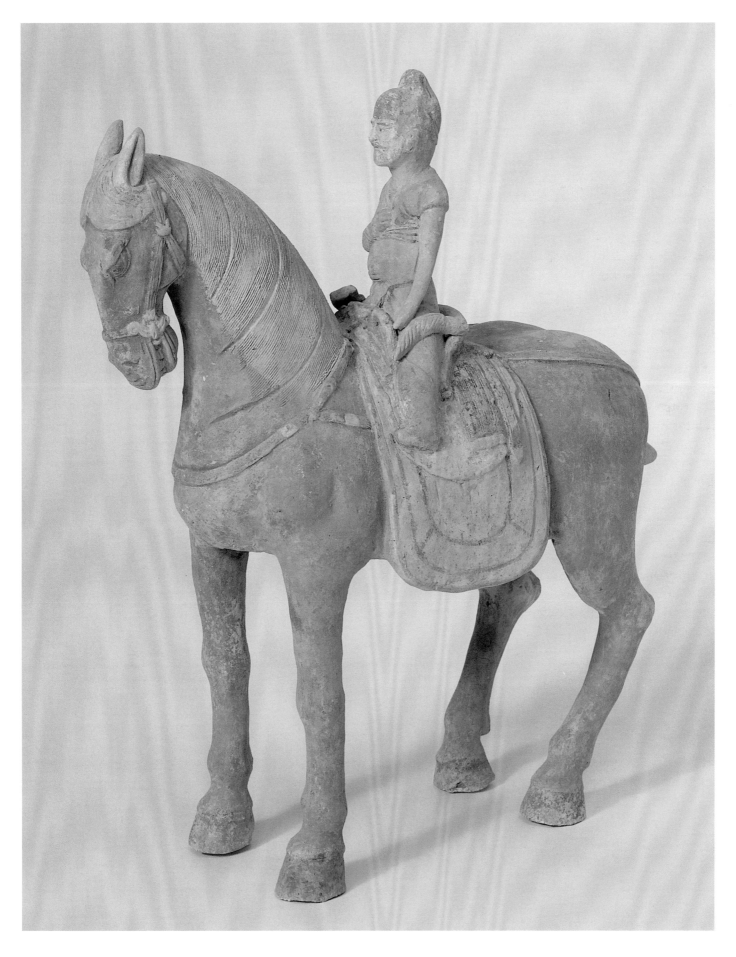

21, 22. TWO POLO PLAYERS

painted earthenware
h: 44.0 and 46.0 cm
Tang dynasty 2nd half of the 7th or 1st half of the 8th century
1995.591 A –B

Polo was introduced from Persia, and favoured by emperor Taizong (627–649), who, seeing it as excellent paramilitary training, demanded that gentlemen practise it. The game became very popular amongst Tang aristocrats, not few of whom had intermarried with, or had descended from Central Asian princesses. The palace itself had its own polo ground.

Like the men from Persia and Turkestan or the Tibetans, the Chinese became skilled polo players. Interestingly, the time of the Tang empire was the only period in Chinese history when the upper class of aristocrats and intellectuals did not despise military and sporting activities and actually indulged in them. It was, as well, the only time when women — court ladies and their attendants — enjoyed some physical liberty. They were allowed to wear men's attire[1] and could be seen on riding outings in the countryside[2] or, as shown by funerary figurines such as these two lively Tsui peces playing a polo (*jiqiu*)[3] game.

The two young ladies wear the *hufu*, or western barbarians' costume: an overrobe with round collar, crossing to the right, belted under the waist, worn over loose pants tucked into boots. Here the collar is left open to allow freedom of movement. The hair of one of the riders is gathered in an asymmetrical shell-shaped bun on top of her head; the other's hair is parted in the middle and gathered in a low bun at the back of her head.

Both horses are jumping — they do not rest on the commonly encountered plaque. Their bodies are very different from the old Chinese tarpan pony from the north, still seen pulling Qin Shihuangdi's parade chariots.[4] They look different, too, from the Han horses which had already been cross-bred with prestigious mounts from Sogdian. The admixture of Arab blood is probable, but so many different foreign stocks were imported at the time that it is impossible to define more accurately their actual breed.[5]

Enough of the polychrome decoration remains and shows the harnessing system made of simple straps without metal ornaments, probably to keep it as light as possible. The saddles are small and are fixed upon short light rugs. The mallets have disappeared, but examples of polo players with their mallets are known from excavations in Xinjiang Tang cemeteries.

The two pieces in the National Gallery of Australia are fine figurines. They can be dated to the second half of the seventh century or the first half of the eighth century and probably come from an aristocratic tomb in the capital area.

1 See *supra*, catalogue no. 14, note 3, on murals in Li Xian's tomb in Qianxian in Shaanxi province, *Zhongguo lidai fushi*, Shanghai: Xuelin CBS, 1984, pl. 232, p. 143, and on several sections of Zhang Xian's horizontal scroll, *Spring Outing on Horseback of the Lady of Guo, ibid.*, pls 233, 234, p. 143.
2 See *supra*, catalogue no. 16, note 8..
3 *Jiqiu* or *daqiu* means 'hit the ball'. The ball was hit with curved sticks, with a crescent-shaped end.
4 *Xi'an, Legacies of Ancient Chinese Civilization*, Beijing: Morning Glory Publishesrs, 1992, pp. 90–91.
5 E. Schafer reminds us, that in 717 the city of Khotan, in what is today Xinjiang, sent a pair of polo ponies to China, *The Golden Peaches of Samarkand*, Los Angeles/London: University of California Press, 1963, p. 66.

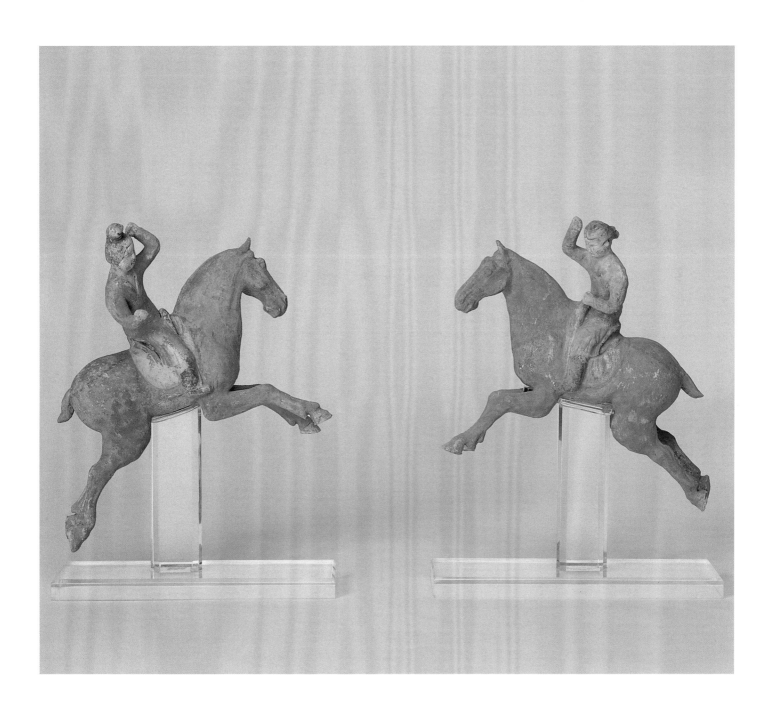

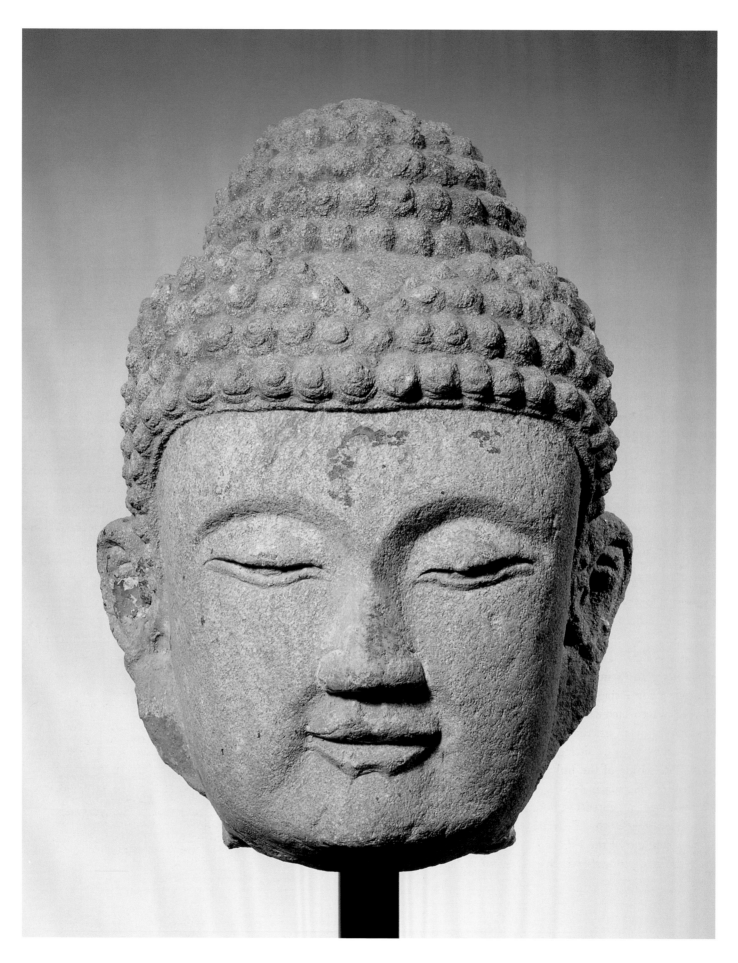

23. HEAD OF A BUDDHA

limestone
h: 46.0 cm
Song dynasty 960 – 1279
1995.596

This beautiful head of a Buddha has probably been cut from a statue, which standing would be about two metres high, in a cave sanctuary where it may have been backed by a stone mandorla or a stela. The lower part of the head at the nape of the neck bears a scar consistent with such a position.

The Buddha is represented with a rather broad rounded *unisha*, or skull protuberance, and with his hair in separate tight round curls. A piece is missing under the *unisha* in the centre of the hair. The face is framed at the top by the stepped limit of the hair; on each side, by the ears — the lower parts of which seem to have been broken; and, at the bottom, by the firm square, but rounded chin and jawline. Beneath the wide rectangular forehead, the symmetrical eyebrows join above the small aristocratic nose. No *urna* (frontal birthmark) appears on the forehead.

The Buddha's expression is serene, with the face treated in a soft and refined modelling. The eyes, half open, are visible between beautifully carved eyelids. The mouth is small and gives a slight smile. The right part of the upper lip seems to bear a light repair, as does the nose.

Traces of a blackish pigment remain at several places on the face — on the forehead and on the lower part of the right cheek. On the right ear, remnants of the same dark pigment appear on a layer of a white plaster-like coating. The custom of painting stone sculpture is commonly encountered in China. It is possible that this Buddha was painted at some stage, or coated with a layer of lacquer. Maybe it was covered with thin leaves of gold — as still applied by pious visitors to sanctuaries in Thailand. A small Northern Song stone statue of a sitting Amitabha Buddha, discovered in the foundation of the Jinhua Thousand Buddha Pagoda and kept in the Zhejiang provincial museum, bears gold leaf on the stone;[1] it is dated 1056–1063.

Stylistically the Tsui head keeps a few traits, in the treatment of the hair and the modelling of the face, from the Tang models which themselves inherited these features from both the northern land route and the southern route through Indochina, coming from the schools of Sarnath and Amaravati. The beautiful distinguished face seems to be illuminated from within. It belongs to a person meditating, but not cut off from the world, full of benevolence and spirituality.

This piece has something in common with wooden sculptures from the Kamakura period in Japan, although it is less austere and, in terms of charm and closeness to human creatures, is nearer to the Indian and Central Asian models.

Not many cave sanctuary sculptures remain untouched. Most Song examples, for instance in Maijishan, have been repaired, sometimes heavily, during the Ming dynasty, which makes them unreliable references. Three Liao dynasty altar statues of Buddha from the Huayan temple[2] in Taiyuan, Shanxi province, although more remote and more impressive because still in situ, have definitely something in common with the head in the National Gallery of Australia's collection, as does a Liao or Jin Buddha made of white marble which O. Siren saw in a private collection in Beijing in the 1920s.

The Tsui piece may have carried a *mani* pearl, like most Song Buddhas[3] or Japan's Kamakura statues, in the space of the hair where a triangular piece is missing.

Because of the scarcity of comparative material, as yet no matching piece seems to be known. However, an early Song date and a northern provenance are proposed.

1 For a photograph of this piece see *Zhongguo meishu quanji,*
The Great Treasury of Chinese Fine Arts, Shanghai: Shanghai meishi quanji,
1988 *et seq.,* Sculpture, vol. 5, pl. 59.
2 Built during the Jin and Liao, Sinicised barbarian dynasties.
Cf. Huayansi, Beijing: WWCBS, 1980, pls 33, 34, 35, 38.
3 *Cf.* O. Siren, *Chinese Sculpture,* New York: Hacker Art Books, 1970, pl. 584
A, and, in a cave of the Wanfosi site, at Zichangxian, to the north of the
more famous Yan'an site in Shaanxi province, a Buddha reproduced in
Wang Ziyun, *Zhongguo diaosu yishu shi,* Beijing: Renmin meishi CBS, 1988,
vol. 2, pl. 591, or in grotto 15 at Maijishan, *cf. Maijishan shiku,* Beijing:
WWCBS, 1954, pl. 45. The Jinhua Thousand Buddha pagoda bears such
a pearl, and a Liao Buddha, kept in the Gugong (Ancient Palace) Museum
in Beijing, bears the pearl at the very place where something is missing,
under the *unisha* on the National Gallery of Australia's piece,
cf. Zhongguo meishu quanji (1988 *et seq.*), vol. 5, pl. 145.

24. Covered jar with five spouts

celadon glazed stoneware
h: 31.3 cm
Five dynasties or Song dynasty 10th century
1995.582

Flaring above its ring base, then tapering in four slightly bulging layers of different heights towards the vertical annular mouth, the organic shape of this jar is reminiscent of a pine cone; while the profile reminds one of an Indian *cikhara* tower, or the receding form of a masonry pagoda.

Five tubes of hexagonal cross-section, affixed at the limit between the first and second layers from the top, do not connect with the inside of the jar. The straw hat shape of the lid is crowned with a knob like a lotus bud and underlined by a small scalloped collar that echoes the horizontal line of the rim of the lid. This knob looks very much like a small *stupa* (architectural Buddhist reliquary).

The jar and its lid bear an incised and combed decoration of lotus petals. Each layer has its own row of petals, except for the top layer which is incised with vertical parallel lines under the plain rim of the mouth.

The piece is entirely glazed — all but inside the tubes, under the foot and under the rim of the lid. The thin, homogeneous, finely crazed, rather glossy glaze is a celadon type. It gathers in density in shallow areas, in the incisions, between layers and between the dome and the rim of the lid.

The function of such jars remains unclear.[1] Found in tombs, they are funerary objects specially made for burial. Their lotus decoration conjurs up a Buddhist context, which is not really in conformity with the date of their making — Five Dynasties and Northern Song period, when Buddhism was still suffering from the setback initiated by the Tang crackdown of 843–845.[2] It would be interesting to know whether representations exist of this type of jar being used during ceremonies. The false spouts may have held incense sticks, flowers, or decorations of some kind.

Sometimes called Lishui type jars, found in Zhejiang, jars with five spouts were produced mainly by the Longquan kilns, but the Yuyao kilns and the Wenzhou kilns are also known to have made them.[3] Of the two closest pieces to the Tsui jar so far found,[4] one is kept in the Hans Popper collection and dates to the Five Dynasties or the Early Song period — it has five undecorated bulging tiers and is covered with a thin crazed olive glaze; the other is part of the Avery Brundage collection and dates to the Northern Song period — it has four tiers, two of which bear an incised decoration of lotus petals, its lower part is incised with vertical lines, its lid bears lotus petal motifs, and its pomegranate-shaped knob rests on a collar reminiscent of the collar of this jar.

The National Gallery of Autralia's jar is quite heavy. It is a fine piece and a good example of one type of the production of the Southern kilns during the Song dynasty.

1 Even their morphological origin is far from clear. They bear sometimes a resemblance to some *duojiaoguan* (jars with many horns), some of which can have several layers, and the horns of which, being unpierced, appear to be without a function. But it is impossible for the time being to track any filial relationship between the two types of vessels. For similarities in the profiles see Lin Zhonggan, 'Fujian Song mu fenqi yanjiu', in KG, 1992/5, fig. 2, illus. 1, 2, 3, 4, 5, 6, 7, 8.

2 We know though that incineration of corpses was widely practised during the Song dynasty in Southern China, *cf.* J. Gernet, *La Vie quotidienne en Chine à la veille de l'invasion mongole, 1250–1276*, Paris: Hachette, 1959, pp. 189–191, and Xu Pingfang, 'Song Yuan shidaide huozang', *Wenwu ziliao*, 1959/9.

3 For an early (Five Dynasties) example, uncovered in a tomb at Sanxi in Longquan county, see *Longquan qingci*, Beijing: WWCBS, 1966, pl. 1. The Shanghai museum keeps a Song *liuguanping* (bottle with six tubes, the mouth of which is treated as a lotus flower, *cf.* WW, 1982/3, pl. 7, illus. 1.

4 *Cf.* R.-Y. Lefebvre d'Argencé, *The Hans Popper Collection of Chinese Art*, Japan: Kodansha, 1973, p. 126 and pl. 81, and d'Argencé, *Avery Brundage Collection, Chinese Ceramics*, Japan: Kodansha, 1967, p. 72 and pl. 26B.

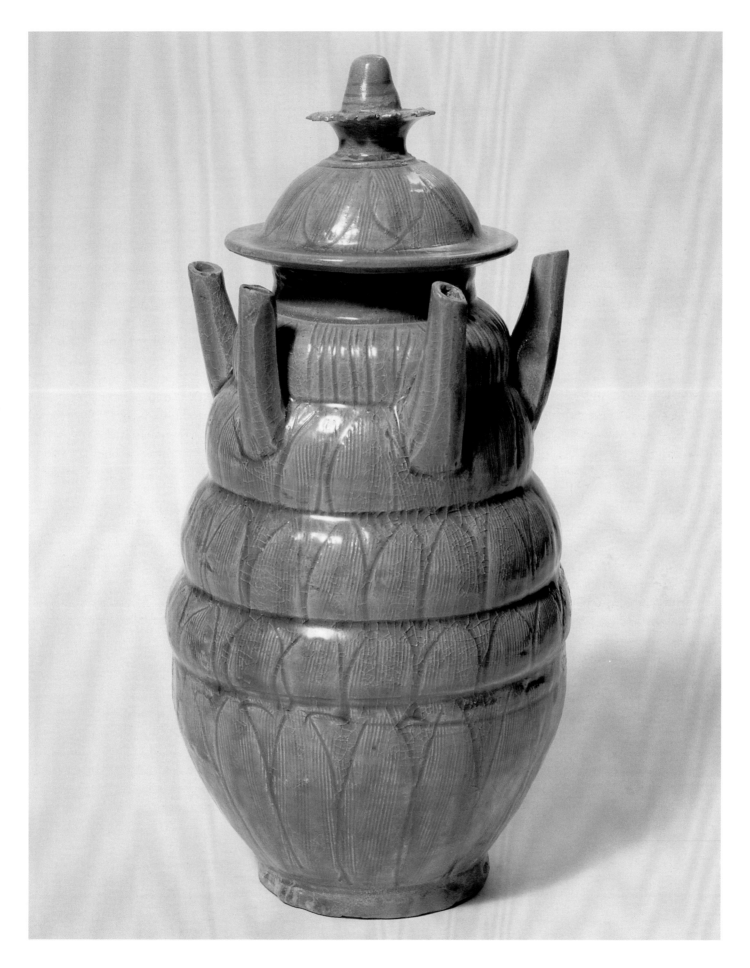

25, 26. PAIR OF FUNERARY URNS

stoneware with *qingbai* glaze and brown underglaze painted decoration
h: 35.5 cm each
Song dynasty late 11th – early 12th century
1995.590 A–B

The two jars are identical in shape: an ovoid belly, flat at the shoulder, with an almost cylindrical neck bulging at the rim of the mouth. Each has a dome-shaped lid bordered with a collar lobed at the rim, and crowned with a bird-shaped knob. At the shoulder, and about the middle of the belly between shoulder and foot, the jars are decorated with an undulating horizontal band in relief, which was luted and pinched while the clay was still damp. On the belly and the neck, the jars bear an underglaze iron brown, freely designed decoration of a dismantled floral scroll. Some of the relief motifs are enhanced with a touch of iron brown.

Both jars carry a complex modelled decoration full of cultural and religious connotations. One is adorned with a long, gaping, sinuous dragon unrolling its body (covered with scales) in a clockwise direction. Its four, five-clawed paws and its rising tail are set around the vessel's neck. Above its horned head, a cloud bears a disc inscribed with the character *yue* (moon). The dragon is accompanied by a standing male figure wearing a hat and carrying something in his joined arms, maybe a chicken. Two objects behind him are difficult to identify. Following them, a man is lying on his back; his head appears to rest on his right arm, his left hand touches his hip. From his waist hangs a cloth (or perhaps a short whisk). Next, a perching bird turns its head outwards. Then there is a spherical object — whether a ball, pearl or peach, it remains unidentified. As does a strange standing object, which may be an animal.

On the second jar, the main decoration consists of a tiger unrolling its serpentine body around the vessel's neck, followed by standing or lying human and animal figures turning in an anti-clockwise direction. On the bulging rim of the mouth, above the head of the tiger, a disc on a cloud bears the character *ri* (sun). The tiger is mounted by a small human rider and is accompanied by a standing, possibly bearded, male figure, keeping his hands inside his sleeves. This man seems to carry something under his right arm at his waist. Behind the man, there is a small animal or a cloud, then an unidentified object which may be a cloud. A dog follows. Behind it lies a prostrate human figure. The last object in the procession looks like a flame or a snake coiling around a ball.

Since the neolithic time the Green Dragon (*qing long*) has been the symbol of the East, and the White Tiger (*bai hu*) the symbol of the West.[1] To the South resides the Red Bird (*zhu que*), and to the North the Black Warrior (*xuan wu*) embodied by a turtle or a snake. In the Chinese cosmogony, the tiger is a solar creature, often seen as the king of the world, thus relevantly represented on the urn bearing the character *ri*. The dragon is an aquatic creature, thus associated with the moon — hence the character *yue* on the other urn. In the *yinyang* system, the dragon is *yin* and the tiger is *yang*.

On the *yin* urn, the Red Bird of the South appears at the end of the procession, whereas on the *yang* urn what should be the Black Warrior of the North seems to appear in the shape of a snake, with head raised and coiling around a spherical object, in what could be a clash of iconography — unless the urns act as a metaphorical map.

The symbols of the four directions (*sifangshen* or *siling*) are present on the pair of urns which act as an entity.[2] Geomancy (*kanyu*) was flourishing during the Song time, and the theme is relevant to the circumstances, since the tomb plot had to be carefully chosen with the help of a master of geomancy in order not to disturb the local god of the earth, which would have brought bad luck onto the sons and grandsons of the deceased.

The figure lying on its stomach (*fuyong*) in a worshipping position is the character known amongst funerary spirits (*mingqi shensha*) as the *futing* (*yong*) character or 'prostrating listening one'. Normally, on the other urn of the pair, echoing him, there is a *yang(guan)yong*, or figure 'raising its head and watching' or 'watching the sky'. The puzzling figure lying on its back with its face turned toward the sky may then be identified as the *yangyong*.[3] Interestingly, some southern tombs have yielded independent figurines of famous mythological characters of popular Taoism, amongst which are *yangyong* and *futing* figures.[4] These are linked to the heavenly world (*tiancao*) and to the funerary world (*mingfu*).[5]

Such urns were made for burial, they appear in tombs by the pair — two or four pairs have been encountered — and were used during ceremonies linked to the funerals.

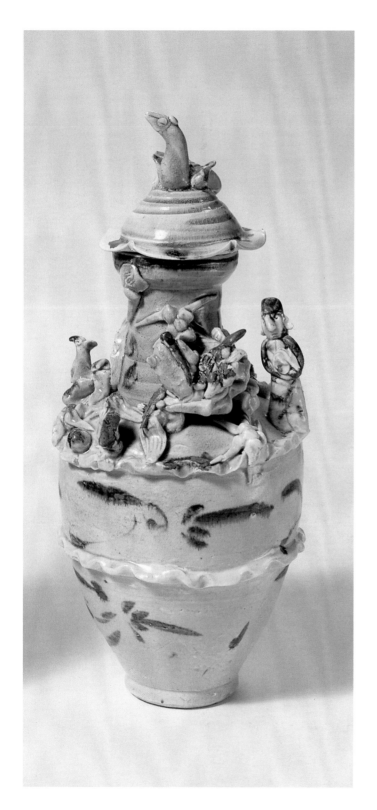

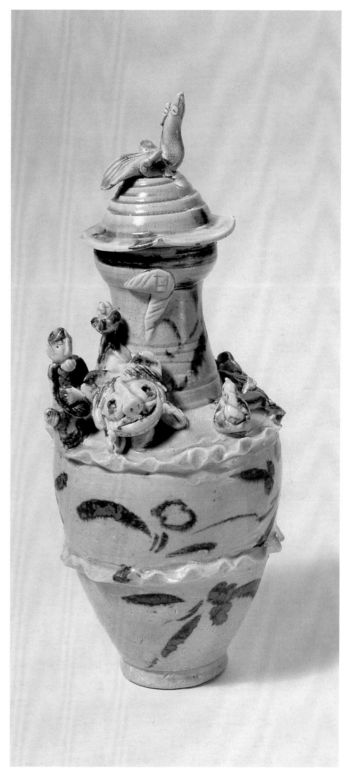

During the Song period, a time of revival for traditional religious beliefs, these urns began to be widely used as grave goods in the provinces of the lower Yangzi basin, mostly but not exclusively in Jiangxi and Fujian, with one atypical example in Hubei. An extraordinary example is known of a Tang dynasty brown glazed grey earthenware funerary jar (h: 84.8 cm) excavated in the 1930s at the Wanyun temple, at Hetang, in Xinhui (Guangdong). This jar, kept in the Guangdong Provincial Museum, bears an elaborate modelled decoration of architectural and Buddhist motifs, and was probably used as a container for the ashes of cremated bones (of a monk ?). Such pieces were also used as food containers. Although geographically excentric, they provide a missing link between the Sanguo and Jin period granary or spirit bottle and some tall and thin southern Song and Yuan urns,[6] some of which could reach heights of nearly a metre. Most of the Song and Yuan jars are *qingbai* (bluish white) glazed stonewares, some of them bear an underglaze brown painted decoration.

Like the *gucangguan*, granary jar, of earlier times, most of these pieces were found containing rice grains. The Linchuan pair was uncovered in a tomb which yielded a land title deed (*dijuan*). The famous Sangtian husband and wife tomb not only yielded urns, Taoist and zodiac figurines, but also a land title deed still partially legible.[7]

An understanding of the relationship between the characters represented on the Tsui urns, some of which belong to the other world's bureaucracy, and the deal that probably had to be made for what we may call the spiritual purchase[8] of the land from the local gods and spirits, would require further research.

Because of their harmonious proportions and their underglazed brown decoration which make them very close to the Pucheng piece,[9] the proposed date for the funerary jars in the National Gallery of Australia would be the transition period between the second and third phase of Song tombs in Fujian: Guangzong-Ningzong reigns (1190–1208) and the proposed provenance would be the Fujian coastal province of China.

The Guimet museum in Paris keeps a fine quality Longquan celadon pair of urns with a dragon and a prostrating figurine. The Cernuschi museum in Paris has a very good pair of *qingbai* urns which look more like Jiangxi pieces.[10]

It would be interesting to research the relationships, in terms of shape and function, between the *gucangguan*, the *niujiaotan*, ox horn jar, the five spouts *guan* and the funerary urns with decoration in relief.[11] The National Gallery of Australia happens to keep three of these probably related types.[12]

1 *Cf.* tomb no. 45 at Xishuipo, in Puyang (Henan) with shell dragon and tiger, properly installed at the east and the west of the defunct, *cf.* WW, 1988/3, p. 4, fig. 5.

2 In 1975 ceramic workers digging at the Xiongjia kiln, Madianzhen in Zhijiang county in Hubei province, excavated a single jar called soul jar (*huntan*) by the authors of the report, bearing different kinds of figurines on the shoulder and the four animals of the orients on its belly, *cf.* WW, 1989/8, pp. 763–764. It is a rare phenomenon. Others normally work in pairs. Relief plaques or figurines of the symbols of the four directions are common amongst grave goods in Song and Yuan dynasties tombs.

3 Several examples are known, for instance on a piece at the Guimet museum in Paris, a pair at the Cernuschi museum in Paris, *cf.* M.-T. Bobot, *Chine connue et inconnue*, Paris: Paris Musées. 1992, pp. 148–150, or from a Southern Song tomb at Linchuan, in Jiangxi province, *cf.* Chen Dingrong, 'Nan Song liniao longhu renwu duisu ciping', WW, 1990/9, p. 96.

4 a) A famous example of 82 figurines dramatically displayed in annex chambers of a Song couple's joint grave, which can be dated to *c.*1100, could give interesting clues for further research on Taoist iconography. See KG, 1988/4, pp. 318–328. It remains a rather common phenomenon in Yuan tombs. b) Among the independent figurines excavated in 1984 from a Yuan dynasty tomb which yielded four beautiful *qingbai* glazed urns (with a *futing* on them), the *yangyong* character, watching the sky, photographed standing, see KG, 1987/3, fig. 4, p. 246, is shown with an arm behind his back, exactly like the character reclining on the shoulder of the National Gallery of Australia's urn. The *futing* is shown at another moment of prostration, raising his head.

5 A Song dynasty tomb at Wenquanxiang, in Linchuan county, Jiangxi province, *cf.* KG, 1988/4, fig. 8, p. 330, which has yielded slightly different, taller, thinner *qingbai* urns, contained as well 70 figurines amongst which 2 *yangguan yong* and 2 *futing yong*, see *ibid.*, pp. 330 and 334 for description and comment. One of the *futing* characters, pl. 5, illus. 4, is shown resting on the earth, his ear on his right hand . One of the *yangyong*, pl. 3, illus. 6, is represented as a civil servant watching the sky.

6 For the remarkable but little known Tang urn, see *Guangdong chutu Jin zhi Tang wenwu (Archaeological Finds from the Jin to the Tang Periods in Guangdong)*, Hong Kong: The Chinese University of Hong Kong, 1985, pp. 206–207. Amongst later tall pieces: the pair from the tomb at Chenjiacun, in Linchuan county (Jiangxi), dated 1st year of Qiandao era (1165), *ibid.*, p. 96, or the pair from Qingjiang (Jiangxi province), dated Baoyou era (1253), *cf.* KG, 1989/7, plate 6, illus. 1, or a piece from Pucheng (Fujian), which can be dated between 1190 and 1208, *cf.*, KG, 1992/5, fig. 2, 20, p. 458, and WW, 1959/3, p. 75.

7 See Chen Boquan, 'Jiangxi chutu "dijuan" zongshu', in *Jiangxi lishi wenwu*, 1981/3, quoted note 6 by Chen Dingrong and Xu Jianchang, KG, 1988/4, p. 334. See *supra* note 4 a).

8 Normally rich families have their clan cemetery on their property. In any case researching the commercial practices regarding tomb land would be of great interest.

9 See *supra*, note 6.

10 See *supra*, note 3.

11 The study would have to cover all provinces concerned. An attempt to clear up the problem was made by Zhou Shirong in an article pertaining only to Hunan, *cf.*, KG, 1987/7, pp. 646–652.

12 Such research could be a good topic for an MA thesis in Chinese art.

27. HEAD OF AN OFFICIAL

limestone
h: 65.0 cm
Yuan or Ming dynasty 13th – 17th century
1995.573

This head has obviously been cut from a high stone statue. From its proportions, the statue was probably about two metres high and may belong to a site of some importance. The volumes are accurate and the face is more individualised than would be expected. The features are strong, with a stern and attentive look and raised eyebrows. The nose is long and higher than the average Chinese nose; the mouth is small and thin. The character represented, without a moustache or beard, can be considered of 'young middle age'. It appears to be the idealised portrait of a virtuous official.

The man is wearing a high bonnet resembling a type known during the Yuan and Ming dynasties.[1] It is attached by a ribbon passing in front of the ears and under the chin; the band above the forehead bears an incised motif; and the grooved central piece of the hat indicates the official's rank.[2] Little roundels on each side of the back part of the hat indicate that both hat and hairbun underneath were fixed with a long horizontal hairpin.

During the Ming dynasty (contrary to what was widely felt in the 1950s),[3] the sculptors produced masterpieces, mostly Buddhist, expressing deep spirituality. But the best works were made of wood or of clay. The northern artists who, during the Song, Liao, Jin and Yuan dynasties, had carved or modelled outstanding statues of expressive *luohan* (*arhat*),[4] elegant *lalitasana*[5] resting Guanyin, and benevolent standing *bodhisattvas*,[6] had obviously well trained epigones who catered to the needs of the temples, refurbished after the Ming emperors restored an indigenous power. *Arhats* and *bodhisattvas* of this time can be of great beauty. Interesting iron religious statues continue to be cast for the temples.

Although the tradition of stone sculpture stays alive in cave sanctuaries, on funerary sites, and at the gates of palaces, as yet no real stone masterpieces are known from the Yuan and Ming periods except for beautiful architectural reliefs.[7] The Dazu caves, in Sichuan province, dating from the Tang to the Qing dynasties, are famous for their 50,000 statues of the three faiths (*san jiao*) — Confucian, Taoist and Buddhist — interesting in many respects but not outstanding. Neither are the works at the Longshan Haotianguan Taoist temple in Taiyuan; nor the statues at the Huangmiao in Sanyuancheng (Shaanxi province).

The *shendao* or spirit roads, which led to a funerary site,[8] have yielded good examples of stone statues of civil servants (*wenchen*) and military officers (*wujiang*) represented in full official gear. As good as some of them may be, all are deprived of spirituality and personal expression.

As for the Tsui piece, the absence of the body and of a costume which could provide information, and the absence of any inscription, make a precise identification difficult. But several hypotheses may be proposed.

The absence of a beard makes it unlikely that the character is a very high ranking court official whose wisdom and power would be enhanced if not symbolised by such an attribute. Nevertheless it is the representation of a gentleman with a good position.

He could have been a eunuch, honoured in his home village, as was Admiral Zheng He (1371–1434) in his province of origin (his family, the Ma, were Moslems from Yunnan) with an official tomb, actually a cenotaph. He could have been a virtuous official or a pious son from an edifying Confucian or Taoist story, represented by a group of statues either in a cave site, such as Dazu, or in a family temple.

He could have been a member of the heavenly bureaucracy in a Taoist temple, or a minor character in a story such as Pi Yunsi's, represented in the Haotianguan caves. One of the minor standing figures between the sitting immortals of cave 2 in the Haotianguan is not unlike this head in style (as far as O. Siren's pl. 611A permits us to see). Unfortunately many other characters have lost their heads, 'scattered in collections all over the world'.[9]

If the very lightly carved, hardly visible motif in the middle of the front band of the hat is not the fortuitous product of erosion but what it seems to be — a very small rabbit seen in profile — this character could even be the personification of one of the famous twelve Chinese animals. It would then represent the Hare (*tu*).[10]

Statues of the twelve 'zodiacal' animals were placed in non-Buddhist temples (*miao*),[11] such as the Yuhuanmiao,[12] in Jincheng (Shanxi). Several of these statues from the Yuan dynasty, treated as officials, wear hats similar to the one

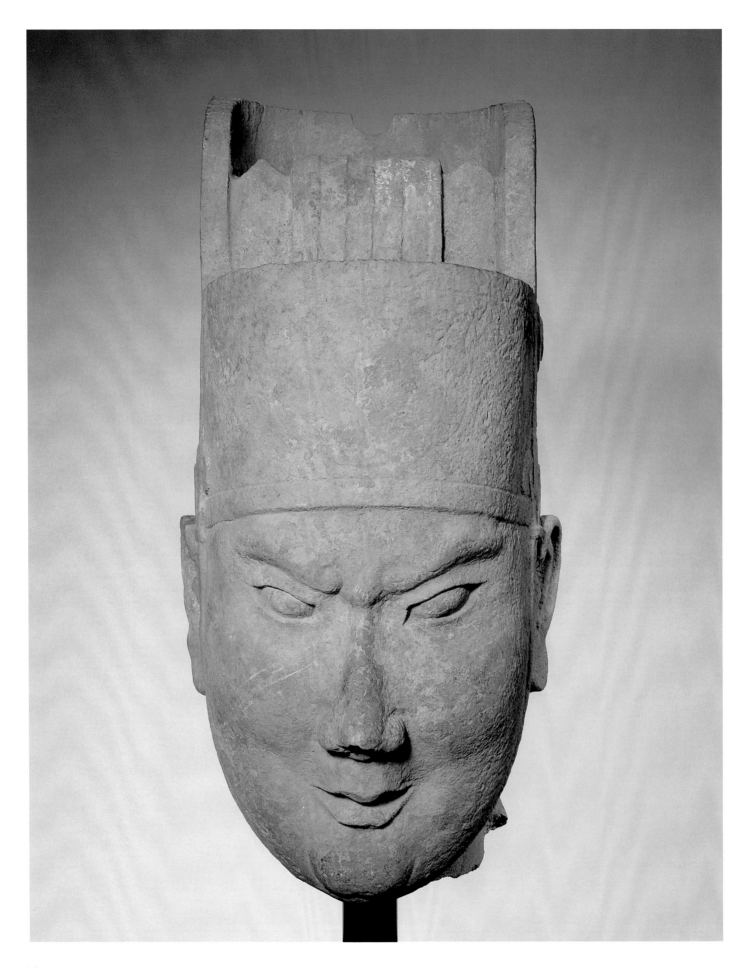

on the Tsui head. These hats are actually *wuliang guan*, worn by second category officials.[13] The front of each hat bears a large disc decorated with the picture of the animal personified by the character.[14]

To summarise, the sculpture, definitely non-Buddhist, could bear a Taoist or a Confucian connotation and may come from a family shrine, a village temple or a cave sanctuary. It could as well come from a grave corridor or from the spirit road leading to the tomb of an affluent and high ranking person. Its geographic origin and provenance remain unknown.

With all the uncertainties regarding a precise identification, this stone head of an official in the National Gallery of Australia may be stylistically assigned to the Yuan or the Ming dynasty and shows the obsession of the Chinese culture with its administration and its main characters, echoed in the world of heaven as well as in the underworld.

1 And inherited from the Tang and Song. It is reasonably close to that of an official represented in Zhou Xibao's *Zhongguo gudai fushi shi*, Beijing: Zhongguo xiji CBS, 1982, p. 387, fig. 4, or p. 394, fig. 7, in both cases a so-called *liang guan*, lintel or bridge hat. The number of *liang* indicates the category of the official: a seven *liang* hat is worn by a first category official; a five *liang* hat by an official of the second category.

2 Something similar to the piece of jade shown on the right side of illus. 425, p. 237 of *Zhongguo lidai fushi*, Shanghai: Xuelin CBS, 1984.

3 See for instance the severe appreciation of Ming and Qing sculpture by Laurence Sickman, in L. Sickman and A. Soper, *The Art and Architecture of China*, Pelican History of Art series, Baltimore: Penguin Books, 1971 (1st publ. 1956), p. 202.

4 *Luohan* (Chinese), *arhat* (Sanskrit) — Buddhist 'saint', 48 of them, famous disciples, often represented in temples.

5 *Lalitasana* — resting position.

6 *Bodhisattva* (Sanskrit) — Mahayana Buddhist 'saint', who has broken the cycle of reincarnation, but who seeks buddhahood through the salvation of others.

7 To mention just a few examples, the Yuan relief of the Jukangguan arch in Hebei province on the way between Beijing and the Great Wall, and the reliefs in the middle way in the courtyards of the Forbidden City.

8 Either to a single mausoleum or a group of tombs. The *shendao*, or spirit road, is bordered by pairs of statues representing mythical animals, real animals as well as civil (*wenchen* or *wenguan*) and military (*wujiang*) officials in court attire. In a classical pattern, the most famous of which remains the site of the Ming emperors' mausoleums in the vicinity of Beijing. Not far from Nanjing, where the first Ming capital was located, some sculptures bordering the way to the Xiaoling and Zuling, mausoleums of Zhu Yuanzhang, founder of the dynasty, and his parents can still be seen.

9 O. Siren, *Chinesische Skulpturen*, Zurich: Museum Rietberg, 1959, p. 162.

10 Linked to planet Jupiter's 12 mansions in its 12-year revolution, the animals, more transcendental than really symbolic, are emblems of the annual cycle, or to put it in a popular manner, they are the calendar's animals. For Chinese chronology is computed by cycles formed by combining 10 Celestial Stems (*tiangan*) and 12 Earthly Branches (*dizhi*, known also as Branches of Horary Characters) which form 'centuries' of 60 years, each year bears the name of one of the 12 animals: 1987 (*dingmao*) and 1999 (*jimao*) are years of the Hare. The Chinese calendar, called peasant calendar (*nongli*) or lunar calendar (*yinli*), is said to have been created by half legendary Emperor Huangdi (the Yellow Emperor) in 2697BC. Since the Shang dynasty (16th–11th century BC) and maybe earlier, the characters of the cycle have been used for official soothsaying as well as family and business horoscopes.

11 They could also stand in another environment: during the Qing dynasty, 12 statues of the zodiac 'animals' were placed around the main pond at the Yuanming *yuan*, the park where the Jesuits built European palaces for Emperor Qianlong, in the vicinity of the Summer Palace, to the west of Beijing. During the Tang dynasty, pottery figurines of the *shengxiao* (with human bodies and animal heads) could be put in tombs, *cf. Xi'an, Legacies of Ancient Chinese Civilisation*, Beijing: Morning Glory Publications, 1992, pp. 238–239. It continued in the Song dynasty.

12 See several photographs of its best preserved statues in Xia Nai, *Zhongguo meishu quanji* Shanghai: Shanghai meishi quanji ,1988 *et seq.*, vol. 6, *Sculpture, Yuanming*.
 a) This temple, famous for the quality of its statuary, still keeps beautiful clay statues of zodiac animals under the form of civil officials. These statues wear hats quite close to the hat of the National Gallery of Australia's piece. They are called *tongtian baoguan* and look like the *wuliangguan* of the Ming dynasty civil officials of second class. It is interesting to note that as early as the Five Dynasties period, the tomb of Wang Chuzhi (buried in 924 at Quyang) contained reliefs of the 12 personifications of the animals. The Ram (see WW, 1996/9, p. 7, fig. 6), under the form of a young official, wears a *qiliangguan* hat, the front of which is very close to the central part of the hat of the National Gallery's piece with its vertical lines in light relief.
 b) Other statues in the Yuhuanmiao represent the 28 zodiacal constellations of Chinese astronomy. The introduction to volume 6 mentions (p. 9 in the paragraph about Taoism during the Yuan dynasty) that the mansions are symbolised by men, women (of different ages) or *gui* (ghosts).

13 *Cf. supra,* note 1.

14 A very important Liao dynasty tomb (dated to 1117), *cf.* Su Bai, 'Guanyu Hebei sichu gumu de zhai', WW, 1996/9, p. 61, fig. 4 and p. 62, has a map of the sky painted on its ceiling. It is a combined map of the 28 constellations (*xiu*), the 12 *gong* mansions and the 12 Chinese divisions of the day ('hours'). The complex relationship between the animals and the stars is quite accurately described. The close relationship between astronomy and astrology could not be clearer. The fourth constellation, the *fang* (house) appears in popular iconography as a quite young man, without a beard. In J.-M. Kermadec, *Les Huits signes de votre destin, Introduction à la pratique astrologique chinoise*, Paris: L'Asiathèque, 1981, p. 53, the fourth constellation or Hare is figured as a young man.

28. HEAD OF AN OFFICIAL

limestone
h: 67.0 cm
Yuan or Ming dynasty 13th – 17th century
1995.574

Like the head of an official (catalogue no. 27) this head has been cut from a rather high statue. The face is of a man in his sixties, slightly overweight, with slanting yet bulging, diverging eyes beneath thick eyebrows. He sports a moustache and a beard, finely incised in light relief.

Ponderous with wealth obtained from power, the character wears a ceremonial hat without any decorative motif. His expression is of self-confidence and physical strength. The rather martial look almost conjurs up Guangong, the God of War, although no iconographical indication pleads for it, and his hat does not appear to have any military reference — the cartouche at the front of the hat bears no legible decoration.

This head is quite different in expression and style from the previous sculpture. Both are made of limestone but have weathered differently.

In May 1995, a seventeenth-century head of an official was exhibited in Paris.[1] Made of grey limestone (h: 43 cm), wearing a more angular hat and displaying a rather angry expression, the head, identified as part of a *shendao*, or spirit road, sculpture, seems to belong to the same category of sculpture, where there are no apparent religious connections. but where cultural references are a reminder of identity, and about the Chinese civilisation itself.

A small sitting stone statue of a civil official (h: 73 cm) was on the market in Taipei in 1995,[2] showing that provincial sites may very well yield surprising and interesting sculptures. With no more clues, the head in the collection of the National Gallery of Australia might be a good example of such a case. Its dimensions make it important.

1 *Cf.* Beurdeley & Cie, *Art de la Chine*, Paris, 18 May 1995, pl. 14.
2 See *Orientations*, May 1995, Li Yin Co. Ltd, advertising pages.

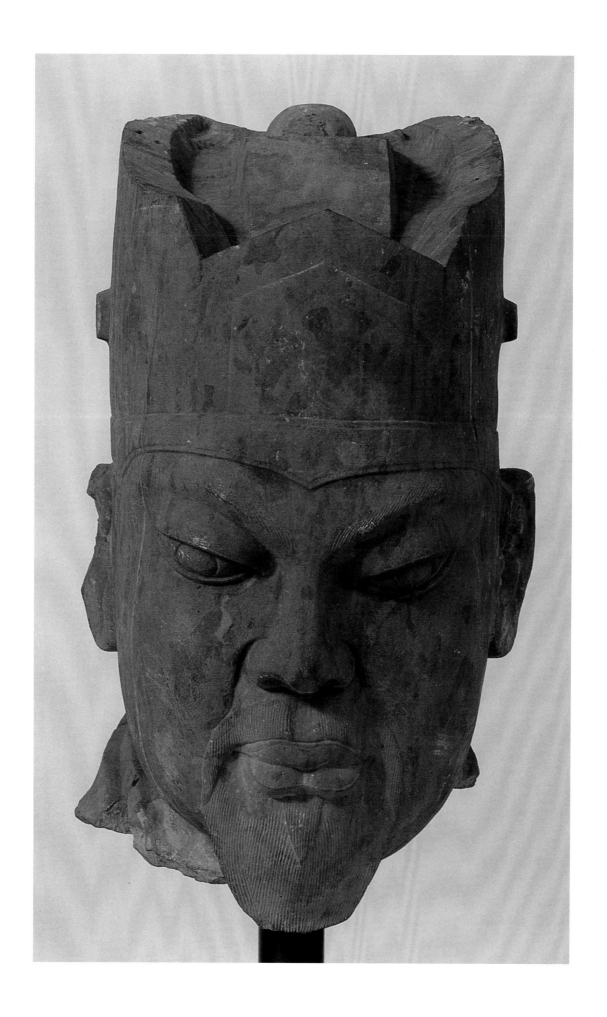

29. HEAD OF AN OFFICIAL

glazed earthenware with painted decoration
h: 40.0 cm
Ming dynasty 1368 – 1644
1995.575

This head is a fine example of the strength of the ceramic tradition in Chinese sculpture. The man, who sports a short moustache and a small underlip beard, has a serene quite impersonal expression. His square hat is of a type seen on officials.

Made of grey clay and covered with a thin transparent glaze, the head is painted under and/or over the glaze to show the details of the hat and the face. The hat, with black border and caramel incised panels at the front, has a diadem-like front

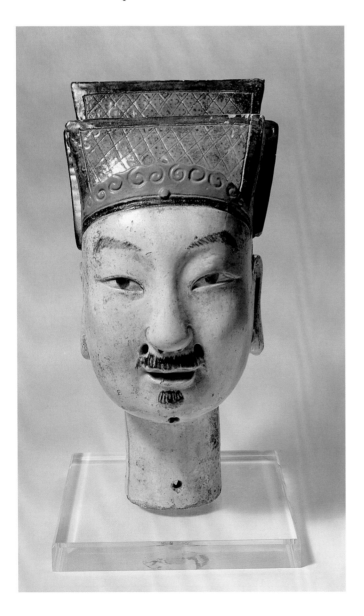

border, incised with curly cloud-like patterns and painted in light brown, just above the black edge resting on the forehead. The medium plane of the hat is treated in a dark blue glaze.

Dark brown has been used for the eyebrows, the moustache and the chin tuft. Two holes above the end of the painted moustache, and another in the middle of the chin, indicate that the figure was meant to be fitted with tufts of real hair to make the long moustaches and beard so often encountered on Chinese literati and officials.[1] The holes on the neck probably mean that the head was attached to the body with little tenons. There is nothing to indicate the material of which the body was made.

The statue, which must have been life-size, could come either from a temple or from a tomb. Since most *mingqi*, tomb figures, dated to the Ming dynasty are smaller,[2] there is a stronger possibility that the Tsui piece, which may represent a virtuous official or a deity, once belonged to a temple.

1 To mention an example of a statue fitted with a 'real' beard and moustache, *cf*., Wang Ziyun, *Zhongguo diaosu yishi shi*, Beijing: Renmin meishi CBS, 1988, vol. 2, pl. 696, one of the *luohan* (*arhat*) of the Qiongzhu Buddhist temple, in Kunming (Yunnan province).
2 Even in Zhu Yuelian's large mausoleum at Fenghuangshan in Sichuan province (although he was Zhu Yuanzhang's grandson and was appointed king of Shi the 11th year of Hongwu), the very fine glazed earthenware *mingqi* are not taller than 84 cm, *cf*., 'Chengdu Fenghuangshan Ming mu', KG, 1978/5, pl. 9.

30. BALUSTER VASE

porcelain with underglaze blue decoration
h: 69.4 cm
Qing dynasty (1644 – 1911) Kangxi period 1662 – 1722
1995.579

The well-balanced baluster shape of this unusually tall vase[1] was much in favour under Kangxi's reign. The fine white porcelain body is made of kaolinic[2] clay (a white-firing not very plastic clay) and *baidunzi* powder[3] (a non-plastic feldspathic substance derived from decayed granite, known as white China stone). Such big pieces were thrown on the wheel in two stages — body and upper part — then assembled and polished, decorated and fired.

The decoration of well-ground cobalt blue[4] was painted on the unfired body. A transparent glaze was then applied, the good quality and the thinness of which has prevented the motifs from blurring, as often occurred a few centuries earlier. After the decoration was complete, the piece was fired at a temperature of between 1,280° and 1,400°C.

The vase is divided in two decorative zones, separated at the shoulder by a transitional register of bamboo leaf[5] motifs framed by two narrower bands of hachured triangles. The tall flaring neck is decorated with a lakescape under the moon — a classical theme of Chinese painting[6] — limited at the top by two parallel lines bordering the mouth under the edge, and at the bottom by a band of hachured triangles between two double lines.

The main decorative space covering the rest of the vase to the base carries a fine landscape of mountains and water (*shanshui*), which is actually the name of this *grand genre* of Chinese painting, treated in the style of the literati.[7] High mountains, in between which trails of mist hover and birds happily fly, overlook a lake; on the banks, temples and leisure pavilions hide amongst tall trees and rocks. The surface of the vase is treated as a horizontal scroll, unrolling space and time from right to left and, with skilfully arranged almost imperceptible transitions, as a series of vertical scrolls.[8]

The first 'hanging scroll' has, as the central motif, a peninsula with its steep mountain cut by a waterfall on one side and harbouring what could be a small temple close to the shore on the other side. In the background, beyond the water, a high mountain curtails the vision of the skyline. In the foreground, a fisherman sitting on the stern of his little boat holds his line, while another sculls further away from the peninsula towards a small bay.

High pine and deciduous trees overshadow the temple. A cluster of taller trees, still with their leaves, close the sequence to the left.

The next section is bordered to the left by strong vertical masses: rocks in the foreground overlooking a small bay punctuated by a bare little tree, a promontory where a solitary man sits meditating or contemplating the scenery; tall trees, one pine and one bare deciduous tree, linking the foreground to the massive block of mountains that overshadow a group of houses built on a small low plain and surrounded by a few trees. The top of the 'scroll' is crowned by a peak protecting an empty leisure pavilion set on a high flat ground.

In the third 'scroll', a dense landscape has as its foreground a small bay on the lake. On a flat area with what appears to be a garden pavilion, a scholar figure stands, maybe listening to the song of the waterfall to his left. A succession of gables and roofs leads the eye towards the sky, half hidden amongst tree foliage and rocky mountains that are cut by a large natural platform overhanging a misty zone above an invisible part of the lake. A cliff and high sharp peaks form the left border.

Human presence makes itself felt in the last 'scroll'. A complex foreground element of a sharp rock is steep to the left and stepped to the right. Under its sheer aspect two scholars, installed above the water in a pavilion on stilts, are absorbed in a conversation or poetical contest. Beyond the water, upon a small promontory in the middle ground, two standing literati admire a waterfall in a cave just below an isolated spot. Its fresh water probably permitted the construction of a hermitage pavilion under beautiful deciduous trees, two of which keep their leaves. The top of their foliage culminates at the level of a clear cut platform that appears almost as high as the peaks in the distance.

Back to the starting point, one cannot help but admire the craftsmen's skill which leads us on a trip through the mountains and on the lake to enjoy the pleasures of the artistic and intellectual elite of sophisticated China.

Such efficiency has its roots in the full understanding of the art of the painter and in the perfect organisation of labour at the kiln.[9] Each labourer of a porcelain workshop

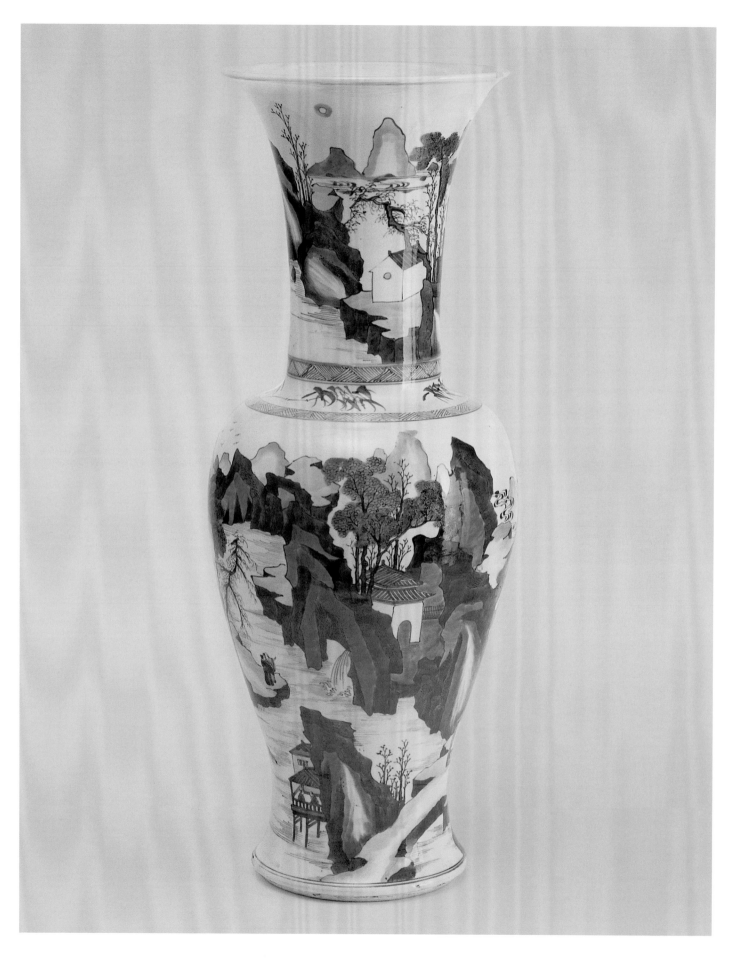

was specialised in a particular type of motif.[10] With repertories of motifs such as *The Mustard Seed Garden Manual of Painting*[11] heavily drawn upon, the piece would pass from one to another until the decoration was completed. Due to the vast experience of traditional monochrome painting, all the nuances of the landscape are rendered with this single cobalt blue colour.

The glazed base of the vase bears an inscription of six characters in a double circle *Da Ming Chenghua nianzhi* — made during the Chenghua era (1465–1488) of the great Ming (dynasty). However, the shape of the vase, the style and the quality of the decoration are not compatible with this date. It was customary during the first period of Emperor Kangxi of the Qing dynasty either not to inscribe the blue-and-white wares or to inscribe them with a fake reign mark of the Chenghua era. The desire to imitate the Chenghua pieces lasted well after Qianlong's accession to the throne.

This fine vase was probably made in an official kiln during the beginning of Kangxi's reign, probably before the reorganisation that took place in Jingdezhen after the inquiry ordered by the emperor in 1680 and the report that was submitted in 1682.

1 Most of them are between 40 and 50 cm high. See for instance a vase in the Umezawa Memorial Gallery in Tokyo, *cf.,* Masahiko Sato, *Chinese Ceramics, a Short History,* New York /Tokyo: Weatherhill/ Heibonsha, 1981, pl. 297, and one in a Japanese private collection, *ibid.,* pl. 298, or He Zhengguan (Ho Cheng-kuang) *et al., Qingdai taoci daquan,* Taipei: Yishuji CBS, 1986, pp. 56, 61, 76. One fine example (h: 46.3 cm) was seen in Australia in 1992, *cf.,* E. Capon *et al., Imperial China,* Sydney: Art Exhibitions Australia Ltd, 1992, no. 88, p. 119.

2 From the Chinese *gao ling* (Wade transliteration system *kao ling*), high hill.

3 Literally 'little white brick', crushed to become a powder and pressed.

4 Its good quality and resistance to the fire probably indicates a Zhejiang origin, maybe from Shaoxing or Jinhua, see He Zhengguan *et al., Qingdai taoci daquan* (1986), p. 13.

5 One of the favourite subjects of literati painters, bamboos were widely represented either by themselves or as part of the three friends: bamboo, pine and prunus. It was a challenge for calligraphers to catch the spirit of their pure, simple and highly mobile silhouette. One of the most remarkable bamboo painters was Xu Wei (1521–1593). It is relevant to find them as a secondary motif on a vase, the decoration of which relies so much on the repertory of literati art.

6 See He Zhengguan *et al., Qingdai taoci daquan* (1986), p. 89.

7 A landscape painting captures the spirit of nature. The act of painting emulates the process of creation of the cosmos. If the painting is good it is full of *qi,* life-giving principle. Nothing more than a landscape painting can give a better idea of the divine creation, hence the highest regard in which this genre was held. The scholars excelled in capturing the truth of things and the breath of life in landscapes, which professional painters, searching for accuracy in the narrow sense of the word, could never entirely achieve, according to Chinese connoisseurs.

8 Besides murals, which had a moral or religious often didactic value and were often created for palaces, temples and mausoleums, the paintings the Chinese enjoyed were album leaves, fan paintings and, most of all, horizontal scrolls, which were meant to be unrolled on long narrow precious tables on occasions, as well as vertical scrolls displayed for a special day or time of the year.

9 See the famous letter written by Jesuit father Père d'Entrecolles, 1 September 1712, to Father Orry, where the work and methods at the imperial kilns of Jingdezhen (*Kim te tchim* for the missionary) are accurately described. In appendix to Stephen W. Bushell's *Chinese Pottery and Porcelain,* Oxford in Asia Studies in Ceramics, Kuala Lumpur: Oxford University Press, 1977, pp. 181–222.

10 *Ibid.,* p. 192.

11 One of the most celebrated volumes, first published in China in 1679. For a good translation and facsimile of the 1887–1888 Shanghai edition, see Mai-Mai Sze, *The Mustard Seed ...,* in Bollingen Series, Princeton: Princeton University Press, 1977.

31. LIDDED JAR

enamelled copper
h: 58.0 cm
Qing dynasty (1644 – 1911) Qianlong period 1736 – 1795
1995.589

Although it is made of metal, this jar has a shape commonly encountered in porcelain. The tapered base rises to form an elongated bulbous body with a harmoniously rounded shoulder leading to a cylindrical slightly inward curving neck. Crowning the vase, the dome-shaped lid has a spherical knob made of a semi-precious stone

The entire surface of the piece is decorated. On a bright imperial yellow background, a polychrome decoration consists of flower, cloud and bat motifs, in pink, lilac, light blue and green. Two white cartouches form the main register, set on the belly between the shoulder and the base, framed by a supple pink border made of four bats (*fu*)[1] extending their wings, the tips of which interlock like vines.

The cartouche offers the brush a noble white surface, where a classical bird and flower (*huaniao* type)[2] painting appears as if on an album leaf. Two little birds perched on branches of tree peonies (*paeonia arborea*) face each other, singing. A branch of Chinese magnolia intertwines with the peony branches and prunus or peach blossoming twigs. In the foreground of one of the cartouches, field orchids show their fine yellow flowers. On the other, the corresponding space is occupied by aster-like flowers. Pierced rocks from the Taihu (Great Lake), much sought after by collectors and literati[3] and commonly encountered in fine Chinese gardens, throw a splash of blue at the base of one of the cartouches among the restrained colours of a delicate palette. While, on the other, the rocks are treated in a light hue of greenish caramel.

Surrounding the cartouches, cloud motifs unroll their subtle pink, lilac, light blue and white scrolls, amongst which auspicious little pink bats fly in all manner of happy and lively postures. A stylised, composite, unrealistic[4] flower punctuates the background between the cartouches.

The beauty of the main decoration is strongly supported by the secondary ornamentation of the jar, which emphasises its structure, dividing it in clear parallel zones. These zones, echoing one another and the scenes in the cartouches, either in shape or in colour, act as instruments in an orchestra support the soloist.

The lid is a zone in itself, where the pink and white petals of stylised peonies contrast pleasantly with the dark green of their leaves. Above this, a register of pink bats in blue *ruyi*[5] shaped frames answers the band on the rim.

A row of walking pink bird–dragons[6] looking backwards decorates the rim of the jar. They are stylised in a vegetal manner. The neck bears a large band of diaper pattern reminding of a trellis in a garden pavilion, or middle-eastern tilework. This band is punctuated by four medallions of (possibly) loquat[7] fruits, leaves and flowers haunted by two fleshy butterflies.[8] A touch of blue echoes the scarce blue areas on the lid and in the cartouche.

A small band of mainly white and pink geometric motifs makes the transition between neck and shoulder. In a loose and poetic association, the top of the band recalls the peonies on the lid, with a strong contrast between pink and green. Smaller pink flowers allow this area to blend harmoniously with the field on which the cartouches play their part. The same game is played at the base of the vase, where a larger band with a row of pink bird–dragons underlines the peonies and their leaves, and echoes the band at the rim.

Not only is the decoration of this jar a masterpiece of the brush, through the quality of the strokes and the subtlety of the colours, but the very organisation of the decorative space is a work of intellectual vigour. Mathematically it is perfectly balanced, and the decoration in itself is symbiotic; as well, it enhances the shape of the object, which makes it an aesthetical success, adding architectural character to a simple shape and giving rhythm to the volume.

The iconography belongs to the stock of cultural references common to poetry and painting, each motif bearing connotations well known to the Chinese elite. The use of clouds as decorative, almost abstract motifs can be traced as far back as the Warring States period (475–221 BC), when their delicate and dynamic scrolls appeared painted with, and on lacquers.

The peony (*mudan*), considered the king of flowers, is often called the flower of riches and honour (*fuguihua*). It is auspicious, conjures up feminine beauty and symbolises the spring season. Its companion the magnolia (*mulan*) which also symbolises feminine beauty, but in a more discreet way, remains a favourite of Chinese gardeners, as does the orchid

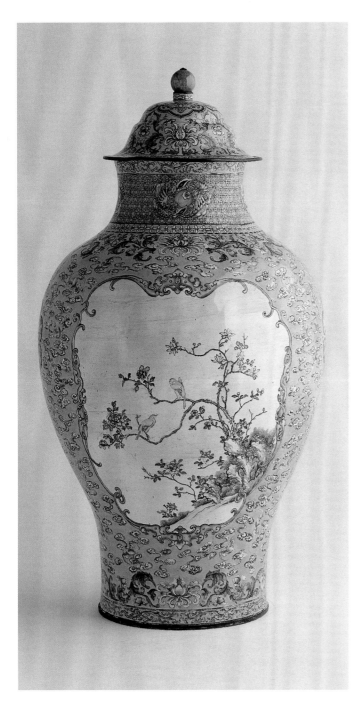

(*lanhua*), modest and yet beautiful. The peach and/or prunus blossoms have inspired generations of Chinese literati and professional painters in their celebration of the spring season.

The garden in China is part of the architecture — one builds a garden, which represents part of the cosmos. The architect of the garden, like the literati painters, emulates the creation of nature. Gentlemen often grew orchids as their hobby. They were very proud of their gardens, where they gathered with friends to write poetry, to paint or practise calligraphy. Many famous gardens have been immortalised by painters.

Enamelled copper plates, boxes and vases have been made in China since the Yuan dynasty; they are called *falang* or *cloisonné*.[9] The *cloison*, or wall, is a small band of metal, soldered to the surface of the piece to prevent each generally pure colour from mixing with its neighbours. Such objects continued to be produced during the Qing dynasty.

However, the Tsui enamelled vase is not a *cloisonné* — the surface is not partitioned. It is a 'painted enamel' (*huafalang*), a type often called Canton[10] enamel. This technique was introduced into China in the late seventeenth century and was well mastered by the eighteenth century. Emperor Kangxi ordered a workshop (*falangchu*) to be created at his palace in Beijing to cater to the court's needs — for its own consumption and for diplomatic gifts. He even assigned two Europeans to the new institution, one was the famous Jesuit painter, Giuseppe Castiglione (whose Chinese name was Lang Shining).

The copper surface[11] is first enamelled with the opaque colour of the background. The piece undergoes a first firing, is then decorated colour by colour and refired until the final stage, as would have been done on a polychrome enamelled porcelain. These were fashionable during the Qing dynasty, especially under Kangxi and Qianlong's reigns. The range of colours for painted enamels is the same as on the famous *famille rose* porcelains.

This piece is remarkable for its colours, particularly the delicate pink of numerous small motifs. Pink was obtained by using gold chloride, and not easy to handle because of its volatility. It is one of the so-called foreign colours (*yangcai*), along with light blue, light green, lilac, bright yellow and white — all of which are present on this elegant vase. Quite often such pieces lack the brightness of their porcelain counterparts, but the Tsui vase does not yield in anything to a porcelain, and could easily be mistaken for one by a lay visitor.

During the Qing period, the Chinese highly appreciated technical prowess. This lidded vase is an excellent example that shows how the craftsmen were in full possession of the skills of their trade. Such pieces were made for the court, the domestic and the foreign markets. European subjects were often represented on the export pieces, especially on objects made in Canton at the peak of the trade between 1735 and 1795.[12]

The National Gallery of Australia's jar, which remains uniquely Chinese in style without any foreign influence, is testimony to the love that the Sons of Heaven felt for nature and plants.[13] Rich in connotations, it links all fields of art. Only a great civilisation with a long history, a very strong culture, huge economic resources and an affluent class

of sophisticated patrons of the arts[14] could devote so much effort to what is, after all, just a piece of decorative art, a minor section of the arts.

The connoisseur, presumably a retired scholar fond of poetry and painting, maybe a collector of antiques, had this vase, with a simple flower arrangement in a Song monochrome on a beautiful rosewood stand in a corner of his studio, not far from his calligraphy table, close to the couch where he meditated or where, inspired by a cup of wine, he played the *qin,* zither, for the pleasure of one or two selected friends.

1 Because of the homophony of its name with the word happiness (*fu*), the bat (not a particularly attractive animal) becomes one of the favourite decorative motifs of the Chinese artists from the 18th century on. It appears in painting on porcelain, and on auspicious images and carved in relief on furniture, or on stone architectural decoration.

2 Although flowers and birds were painted very early on in Chinese art history, it is only during the 11th century, during the Song dynasty that the genre was given its name. Emperor Huizong (r. 1101–1125) was a master of this genre and set the standards for the painters in the Song Painting Academy. During the Ming and Qing dynasty this topic was much in favour beside the noble genre of landscape painting. Both genres provided the painters–decorators of porcelain a rich source of inspiration for blue-and-white as well as polychrome, *wucai* (five colours), *famille rose* and *famille verte* porcelains. The painters who worked on enamels during the Qing dynasty could belong to the elite of Chinese painting, especially in the Beijing imperial workshop. See *infra.*

3 In whose paintings they often appear. The emperors themselves kept some in their collections for their studio and their garden, see, B. Yang, L, Ledderose *et al., Palastmuseum Peking Schätze aus der verbotenen Stadt,* Berlin: Insel Verlag, 1985, p. 134, fig. 82, 83.

4 To mention just one little thing: three small lotus petals appear in the middle of each side of the flower, acting as a pendant at the end of a 'string of pearls', they blend very well into the motif and do not ruin its harmony.

5 Decorative sceptre motif. The *ruyi* sceptre seems to appear during the late Ming dynasty. Possibly an object of every day life originally, it became a talisman and an auspicious gift. Its presence among bats and spring flowers is perfectly relevant.

6 Dragon borders are often encountered on fine painted enamels, see for instance a Qianlong fish bowl kept at the Gugong Museum in Beijing, *cf. Zhongguo meishu quanji,* Shanghai: Shanghai meishi quanji, 1988 *et seq.,* vol. 10, pl. 344, p. 192,

7 Loquats (a kind of medlar) bear fruits at the end of the spring season and the beginning of summer. The magnolia blossoms in the cartouche have already started dropping petals, the twigs start growing leaves, the peonies are in full blooms which would plead for a late May or a June date in Northern China.

8 The butterflies' wings are treated in a manner reminiscent of the way loquat leaves are treated on porcelain decoration, *cf.* a large blue-and-white Ming plate from the R. P. Griffing collection, in M. Medley, *The Chinese Potter,* Oxford: Phaidon, 1976, pl. 145, p. 199, which would confirm the identification of the fruits as loquats.

9 Possibly imported from Byzantium or from France, an influence from the porcelain centre of Limoges (France), also famous for its enamels during the Middle Ages, cannot be excluded on *cloisonnés* as well as on painted enamels. Supporting this theory, Masahiko Sato, *Chinese Ceramics, a Short History,* New York/Tokyo: Weatherhill/Heibonsha, 1981, p. 227, pl. 313, takes the example of two Chinese *famille rose* tea cups kept in the Musée Guimet in Paris, which bear the initials I L for Jacques Laudin I (1627–1695) 'a master of *cloisonné* ware in Limoges. The cups are apparently carefully executed copies of Laudin's work, even down to his mark by a Jingdezhen potter'. *Cf.* also Sir Harry Garner, *Chinese and Japanese Cloisonné Enamel,* London, 1962. See also Liu Wanhang, 'Zhongguo jingtailan de yuanlai: jian tan chicuo jishu' (Origin of Chinese *cloisonné* enamels, techniques of manufacture), in *Gugong wenwu yuekan,* Beijing: 1985, vol. 1, pp. 68–74. For a good photograph of the Guimet Chinese copies of Laudin's cups see J.-P. Desroches *et al., From Beijing to Versailles, Artistic Relations between China and France,* Hong Kong: HK Council, 1997, p. 317

10 Workshops in this area were of tremendous importance for the diffusion of the technique and decorative motifs of painted enamels in China, through tribute to the court as well as through exchanges of craftsmen. See Y. Boda, 'The Characteristics and Status of Guangdong Handicrafts as seen from Eighteenth Century Tributes from Canton in the Collection of the Former Qing Palace', (exhibition catalogue) 'Tributes from Guangdong to the Qing Court', 1987. See also Liu Wanhang, 'Huafalang yu Caiseguo', GGBWYYK, 1983, vol. I, 3, pp. 83–86,

11 Silver can be used as well as gold. See for instance a Qianlong set of two ewers on their basin made of gold and decorated with *cloisonné* and painted enamels, kept in the Musée national du Château de Fontainebleau, *cf.* M. Pirazzoli-t'Serstevens, in G. Béguin *et al., La Cité interdite, vie publique et privée des empereurs de Chine,* Paris: Paris musées et AFAA, 1996, fig. 82, p. 95, or *ibid.,* a silver box from the Gugong museum, M. Köppel-Yang, pl. 78, p. 216.

12 The Musée de la Compagnie des Indes in Lorient (Brittany, France) conserves a remarkable enamelled copper vase with four cartouches of European landscapes with buildings and figures reminiscent of the Limoges style, on a ground of floral scrolls, obviously made for the European market. In return such subjects influenced Chinese traditional motifs which were sometimes treated according to the rules of European perspectives. See J.-P. Desroches *et al., From Beijing to Versailles* (1997), pp. 318–319.

13 As could be an album page in a series of four, this vase seems to be devoted to the spring season. Perhaps three other similar pieces were made to celebrate summer, autumn and winter.

14 The first of all being of course the emperor himself. At times of greatness and self-confidence, such as under the Han, the Tang and the Qing dynasty particularly, imperial patronage of art is a key factor in the birth of a style or in the happy acceptance of new and foreign modes or techniques

Bibliography

General

Chinese archaeological magazines from mainland China —
 Wenwu (WW), *Kaogu* (KG), *Kaogu xuebao* (KGXB), *Gugong
 bowuyuan yuankan* (GGBWYYK) — are primary sources.
 Nothing of real scholarship may be achieved without reading these
 publications in Chinese. They are not translated. They publish
 preliminary excavation reports, the main source of information
 besides special publications, by Wenwu Chubanshe (Archaeological
 Publishing Company, WWCBS), Beijing. *Gugong wenwu yuekan*
 (GGWWYK) from Taiwan is of great interest as well.

The Cambridge History of China, 11 vols, Cambridge: Cambridge
 University Press, 1979–94.

Cahill, James, *Chinese Painting*, Geneva: Skira, 1960.

Chang, Kwang-chih, *The Archaeology of Ancient China*, Yale:
 Yale University Press, 1st edn 1963, regularly revised and enlarged.

Great National Treasures of China, Taipei: National Palace Museum,
 rev. edn 1992.

Lee, Sherman, *A History of Far Eastern Art*, New York: Abrams (1964),
 4th edn 1982.

Rawson, Jessica, *Ancient China, Art and Archaeology*, London:
 Trustees of the British Museum, 1980.

Rawson, J. (ed.), *The British Museum Book of Chinese Art*,
 London: British Museum Press, 1992.

Sullivan, Michael, *Introduction to Chinese Art*, London:
 Faber and Faber, 1961,

WWCBS, 1987 *et seq.*, all fields of Chinese art and archaeology
 are covered.

Zhongguo meishu quanji, *The Great Treasury of Chinese Fine Arts*,
 60 vols, Shanghai: Shanghai meishu quanji, 1988 *et seq.*,

Recent exhibitions of Chinese art and archaeology

Capon, Edmund, Menzies, Jackie and Yang Yang, *Imperial China:
 The Living Past*, Sydney: Art Exhibitions Australia Ltd, 1992.

Desroches, Jean-Paul *et al.*, *From Beijing to Versailles, Artistic Relations
 between China and France*, Hong Kong, 1997.

Fong, Wen C. and Watt, C.Y. James, *Possessing the Past: Treasures from
 the National Palace Museum, Taipei*, New York: Abrams, 1996.

Rawson, Jessica, *Chinese Jade from the Neolithic to the Qing*, London:
 British Museum Press, 1995.

Rawson, J. (ed.), *Mysteries of Ancient China: New Discoveries from the
 Early Dynasties*, London: British Museum Press, 1996.

Works cited in this publication

Andersson, J.G., 'Prehistory of the Chinese', *Bulletin of the Museum
 of Far Eastern Antiquities*, 15, 1943.

Archéologie, Les Grands Atlas Universalis, Encyclopaedia Universalis,
 Paris, 1985.

Archaeological team for the Ming tombs, 'Chengdu Fenghuanshan
 Ming mu' (The Ming tombs at Fenghuangshan in Chengdu),
 Beijing: KG, 1978/5.

Bagley, Robert, *Shang Ritual Bronzes in the Arthur M. Sackler Collection*,
 Washington DC/ Cambridge, Mass.: Harvard University Press, 1987.

Béguin Gilles *et al.*, *La Cité Interdite, vie publique et vie privée des
 empereurs de Chine*, Paris: Paris Musées et AFAA, 1996.

Bobot, Marie-Thérèse, *Chine connue et inconnue*, Paris:
 Paris Musées, 1992.

Brinker, Helmut and Fischer E., *Treasures from the Rietberg Museum*,
 New York: Asia House Gallery, 1980.

Bushell, Stephen W., *Chinese Pottery and Porcelain*, Oxford in Asia
 Studies in Ceramics, Kuala Lumpur: Oxford University Press, 1977.

Changsha Mawangdui yihao Han mu, Beijing: WWCBS, 1973.

Chen Dingrong, 'Nan Song liniao longhu renwu duisu ciping'
 (Southern Song ceramic vase with birds, animals, tiger and dragon,
 and human beings), Beijing: WW, 1990/9.

Ciarla, Roberto *et al.*, *Cina a Venezia, From the Han to Marco Polo, China
 in Venice*, Milan: Edizioni Electra, 1986.

Desroches, Jean-Paul, *La Chine des origines*, Paris: RMN, 1994.

Desroches, J.-P., *Chine, Des Chevaux et des hommes*, Paris: RMN, 1995.

Desroches, J.-P. *et al.*, *From Beijing to Versailles, Artistic Relations between
 China and France,* Hong Kong: HK Council, 1997.

Elisseeff-Poisle, Danielle and Desroches J.-P., *Zhongshan: Tombes des rois
 oubliés*, Paris: MAE, AFAA, 1984.

Esson M. Gale, *Discourses on Salt and Iron*, Sinica Leidensia, vol. 2,
 reprinted Taipei: Ch'eng Wen Publishing Company, 1973.

Fong Wen, *The Great Bronze Age of China*, New York: The Metropolitan
 Museum, 1981.

Gansu Museum *et al.*, 'Lanzhou Tugutai Banshan-Machang wenhua
 mudi' (Banshan-Machang Tugutai Cemetery in Lanzhou),
 Beijing: KGXB, 1983/2.

Gansu Provincial Museum, *Gansu caitao* (Painted Pottery fom Gansu),
 Beijing: WWCBS, 1979, 1984.

Gao Wen, *Sichuan Handai huaxiang zhuan* (Han Dynasty Pictorial
 Bricks of Sichuan), Shanghai: Renmin meishu CBS, 1987.

Garner, Sir Harry, *Chinese and Japanese Cloisonné Enamel*, London, 1962.

Gems of China's Cultural Relics, Beijing: WWCBS, 1990.

Gernet, Jacques, *La Vie quotidienne en Chine à la veille de l'invasion
 mongole, 1250–1276*, Paris: Hachette, 1959.

Gernet J., *Le Monde chinois*, Paris: Armand Colin, 1972.

Girard-Geslan, Maud, 'An Exceptional Horse at the Musée Guimet',
 Orientations, Hong Kong, August 1993.

Girard-Geslan, M., 'L'âge du bronze', in J.-P. Desroches, *La Chine des
 Origines*, Paris: RMN, 1994.

Girard-Geslan, M., *Bronzes archaïques de Chine, Trésors du musée Guimet*,
 Paris: ARAA, 1995 (bilingual French, English with Chinese captions).

Guangxi Guixian Luobowan Han mu (Han Tombs at Luobowan in
 Gui county, Guangxi), Beijing: WWCBS, 1988.

Guangzhou Han mu (Han Tombs in Guangzhou), Beijing:
 WWCBS, 1981.

Han Tang bihua (Murals of the Han and Tang), Beijing: WWCBS, 1974.

Ho Cheng-kuang (He Zhengguan) *et al.*, *Qingdai taoci daquan*
 (Large Selection of Ceramics from the Qing period), Taipei:
 Yishujia CBS, 1986.

Huayansi (The Buddhist temple of Huayan), Beijing: WWCBS, 1980.

Institute of Archaeology, Academy of Social Sciences, *Yinxu Fu Hao mu*
 (The Tomb of Lady Hao), Beijing: WWCBS, 1980.

Jiaoxian Sanlihe (Sanlihe in Jiao County), Beijing: WWCBS, 1988.

Keightley, David N. (ed.), *The Origins of Chinese Civilization*, Berkely,
 LA/London: UCLA Press, 1983.

Kermadec, Jean-Marie, *Les Huits signes de votre destin, Introduction à la pratique astrologique chinoise*, Paris: L'Asiathèque, 1981.

Lefebvre d'Argencé, René-Yvon, *Avery Brundage Collection, Chinese Ceramics*, Japan: Kodansha, 1967.

Lefebvre d'Argencé, R.-Y., *The Hans Popper Collection of Chinese Art*, Japan: Kodansha, 1973.

Lefebvre d'Argencé, R.-Y., *Bronze Vessels of Ancient China in the Avery Brundage Collection*, San Francisco: Asian Art Museum, 1977.

Lefebvre d'Argencé R.-Y. (ed.), *Treasures from the Shanghai Museum*, San Francisco/Washington DC, The Asian Art Museum of San Francisco, 1984

Laufer, Bertold, *Chinese Pottery of the Han Dynasty*, Rutland, Vermont and Tokyo: Charles E. Tuttle Company, 1970.

Lin Zhonggan, 'Fujian Song mu fenqi yanjiu' (Research on Song tombs in Fujian), Beijing: KG, 1992/5.

Li Xueqin, *The Wonder of Chinese Bronzes*, Beijing: Foreign Language Press, 1980.

Liu Wanhang, 'Zhongguo jingtailan de yuanlai' (Origin of *cloisonné* enamels), Beijing: GGWWYK, 1985, 1/3.

Loehr, Max, *The Great Painters of China*, New York: Harper & Row, 1980.

Longquan qingci (Longquan Celadons), Beijing: WWCBS, 1966.

Ma Chengyuan, *Zhongguo qingtong qii* (Chinese Bronzes), Shanghai: Shanghai guji CBS, 1988.

Maijishan shiku (The Maijishan Caves), Beijing: WWCBS, 1954.

Mawangdui yihao Han mu (Han tomb 1 at Mawangdui), Beijing: WWCBS, 1973.

Mancheng Hanmu faque baogao (Excavation Report of Han Tombs at Mancheng), Beijing: WWCBS, 1980.

Medley, Margaret, *The Chinese Potter*, Oxford: Phaidon, 1976.

Menzies, Jackie, *Asian Collection*, Sydney: Art Gallery of New South Wales, 1990.

Mino, Yutaka *et al.*, *Masterpieces of Chinese Arts from the Art Institute of Chicago*, Osaka: Museum of Oriental Ceramics, 1989, in Japanese.

Qin Shihuangdi bingmayong keng yihao keng faque baogao (Excavation Report of Soldiers and Horses pit no.1 of Qin Shihuangdi), Beijing: WWCBS, 1988.

Peking Museum of Chinese History, *7000 Years of Chinese Civilization*, Milan: Silvana Editoriale, 1983.

Pang Mae Anna, *An Album of Chinese Art*, Melbourne: National Gallery of Victoria, 1983.

Quanguo chutu wenwu zhenpin xuan 1976–1984 (A Selection of Precious Chinese Excavation Cultural Relics), Beijing: WWCBS, 1987.

Rawson J., *Western Zhou Ritual Bronzes from the Arthur M. Sackler Collections*, Washington DC/Cambridge, Mass.: Harvard University Press, 1990.

Sato Masahiko, *Chinese Ceramics, a Short History*, New York/Tokyo: Weaterhill/Heibonsha, 1981.

Schafer, Edward H., *The Golden Peaches of Samarkand*, Berkely, LA/London: University of California Press, 1963.

Shangraw, Clarence, *Origins of Chinese Ceramics*, New York: China Institute of America, 1978.

Schloss, Ezechiel, *Art of the Han*, New York: China House Gallery, 1979.

Segalen, Victor, *The Great Statuary of China*, Chicago: The University of Chicago Press, 1978.

Shandong Provincial Bureau for Cultural Relics and Qinan City Museum, *Dawenkou*, Beijing: WWCBS, 1974.

Shanxi Province Institute of Archaeology, *Shangma mudi* (The Shangma Cemetery), Beijing: WWCBS, 1994.

Shaanxisheng bowuguan (Shaanxi Provincial Museum), Beijing: WWCBS, 1990.

Shaanxi Institute of Archaeology, *Shaanxi chutu Shang Zhou qingtong qi* (Shang and Zhou Bronzes excavated in Shaanxi), Beijing: WWCBS, 1980.

Shen Zhiyu, *The Shanghai Museum of Art*, New York: Abrams, 1985.

Sickman, Laurence and Soper, Alexander, *The Art and Architecture of China*, Pelican History of Art Series, Baltimore: Penguin Books (1956) 1971.

Siren, O., *Chinese Sculpture*, New York: Hacken Art Books, 1970.

Sun Ji, 'Tangdai de maju yu mashi' (Horse harness and ornaments in the Tang period), Beijing: WW, 1981/10.

Sze Mai-Mai, *The Mustard Seed Garden Manual of Painting*, Bollingen Series, Princeton: Princeton University Press, 1977.

Wang Ziyun, *Zhongguo diaosu yishu shi* (History of Chinese Sculpture), Beijing: Renmin meishu CBS, 1988.

Wenhua dageming qijan chutu wenwu (Cultural Relics excavated during the Cultural Revolution), Beijing: WWCBS, 1973.

Xia Nai, Feng Xianming *et al.*, *Zhongguo meishu quanji* (The Great Treasury of Chinese Fine Arts), Shanghai: Shanghai meishu quanji, 1988 *et seq.*, 60 vol. publication in progress.

Xi'an, Legacies of Ancient Chinese Civilization, Beijing: Morning Glory Publishers, 1992.

Xihan Nanyue wang mu, Beijing: WWCBS, 1991.

Yang Boda, Ledderose Lothar *et al.*, *Palastmuseum Peking Schätze aus der Verbotenen Stadt* (Beijing Palace Museum Treasury from the Forbidden City), exhibition catalogue, Berlin: Insel Verlag, 1985.

Yin Shenping (ed.), *Tang mubihua zhenpin xuancui*, Xi'an: Shaanxi Renmin meishu CBS, 1991.

Zhang Hongxiu, *Highlights of the Tang Dynasty Frescoes*, Xi'an: Shaanxi renmin meishu CBS, 1991.

Zhongguo bowuguan (Chinese Museums), Beijing: WWCBS, 1984 *et seq.*, publication in progress.

Zhongguo chutu wenwu (Cultural Relics excavated in China), Beijing: Waiwen CBS, 1972.

Zhongguo lidai fushi (Chinese Costumes and Ornaments), Shanghai: Xuelin CBS, 1984.

Zhongguo lishi bowuguan (Chinese National Museum of History),Beijing: WWCBS, 1981.

Zhongguo gu qingtong qi (Chinese Bronzes), Beijing: WWCBS, 1976.

Zhongguo taoci: Yueyao (Chinese Ceramics: the Yue pieces), Shanghai: Shanghai renmin meishu CBS, 1983.

Zhongguo yinyue cidian (Dictionary of Chinese Music), Beijing: Institute of Musical Research, Renmin yinyue CBS, 1984.

Zhou Xibao, *Zhongguo gudai fushi shi* (History of Chinese Costume), Beijing: Zhongguo xiju CBS, 1984.

T ook

An associate College of the University of Kent